A Traveler's Guide

To

Art Therapy Supervision

Monica Carpendale

ISBN: 978-1-4269-8991-9 (sc)
ISBN: 978-1-4269-8992-6 (e)

Trafford rev. 10/10/2011

 www.trafford.com

North America & international
toll-free: 1 888 232 4444 (USA & Canada)
phone: 250 383 6864 ♦ fax: 812 355 4082

Other books by Monica Carpendale

Carpendale, Monica. (2009) Essence and Praxis in the Art Therapy Studio. Victoria BC: Trafford Pub.
Parker, Blake. Carpendale, Monica. Editor. (2011) Laughter at my Window. Victoria BC: Trafford Pub.

The cover image is a pencil and graphite drawing by Monica Carpendale entitled Bird in a Cage. It is a post session drawing done after a parent and teen dyad art therapy group.

Dedicated to art therapy students, supervisees and supervisors

 Remember to have compassion for yourselves and others as you take this role in the world. You will be witness to much pain, the territory of 'hell' will become familiar, and you may feel isolated in your relationships within family and community. Remember that good supervision is one of the best antidotes to compassion fatigue and that maintaining a good practice of self care is integral to doing the work. If you are not taking care of yourself you will not be able to take care of others. But most important is having your own creativity sustain and give expression to your spirit. You will also be witness to insight, growth and joy.

 The development of the art based approach to supervision is intended to access the tacit dimensions of our own inner knowing. Bring art making into sessions with your clients, bring art and art making into supervision, and keep creativity, art and art making central in your life.

 Sincerely,

 Monica J. E. Carpendale

Clay bowl

Carved in soft clay
Soul hollowed by pain
The press of grief against clay walls
High and thin
Fragile
Grace and beauty
Clarity
The bowl deepens
Forms
Tempered by fire
Compassion
The bowl - ready now
To be filled
To overflow
With love.

Monica Carpendale

PREFACE

*All gardeners need to know when to accept something
wonderful and unexpected, taking no credit except for letting
it be. (Allen Lacy)*

A Traveler's Guide to Art Therapy Supervision uses the metaphor of
open ended exploration - a journey towards understanding. The book has
been written for students, supervisees and supervisors. It is a pilgrimage
of sorts – a wandering, a muddling along and circling to find a way into
the centre. The intention is to explore the process of supervision with
a primary focus on the internal frame of reference with regards to the
traveler's mind and the pattern of the unfolding journey of supervision.

The book is written with a combination of theory and creative activities
intended to deepen the exploration. There is an underlying psychoanalytic
and existential framework, with the method and process presented based
on social constructivism, metaphor theory and key concepts in hermeneutic
phenomenology. The application of these concepts and some of the specific
art based activities in supervision evolved directly out of work training
art therapists. The ideas and exercises have been honed by a continual
awareness of cultural considerations. Although key aspects of ethics,
culture and transference set the groundwork for aspects of supervision they
will not be covered to the depth they have with other authors.

The purpose of this book is three-fold: to be a supervision handbook
for art therapy students; to be a self or peer supervision resource for
professional art therapists; and to provide a framework for training art
therapy supervisors.

While the book does focus on art therapy supervision, I believe that
it is of value and relevant to expressive therapy and to supervision of all
therapists, in general. For the beginning supervisee it will provide the

backbone for understanding the process of supervision and support the supervisee in learning how to make the best use of supervision. For the experienced therapist it includes a theoretical overview for becoming a supervisor and for peer or self supervision. I hope that the book can be of value and do justice to what I have learned from my supervisees, supervisors and fellow professional art therapists.

TABLE OF CONTENTS

Acknowledgements

My own learning continues to be inspired by art therapy colleagues at conferences, workshops, books as well as personal experience from being a supervisee, a supervisor, and supervising other supervisors. As much as possible I have referenced the material or acknowledged the individuals that have influenced my thoughts, but my sincere apologies if ideas, phrases, or concepts have resonated and integrated so deeply into my thoughts and work that I may not have noted nor realized where it originated. My own ideas develop very much in dialogue with others and for this I would like to thank the following people: Lois Woolf, Talia Garber, Katharyn Morgan, Judith Siano, and Jan Souza. I would especially like to thank Jacqueline Fehlner for her thorough editorial work and suggestions regarding the book and for the ongoing dialogue and thoughtful inspiration. I would also like to thank my staff, in particular, Jennifer Hakola, for her support and insistence that the book is completed. Also I am indebted to the KATI academic council and the supervisors at the Kutenai Art therapy Institute for their support and contributions to the ideas and development of this book.

To my late partner, Blake Parker, I am grateful for the ongoing support and challenging dialogues that have contributed fundamentally to the evolution of my thought and process. I appreciate my mother for her unswerving faith, love of family, generosity of spirit and commitment to community. From my father, I learned to see the group as an organism, the belief that children must be heard, and that life is a process of questioning, learning and always evolving. In particular, he introduced to me concepts of cybernetics, synergy, communication theory and group dynamics which have been fundamental to the development of my ideas and style as an educator.

THE INTENTION

The best things that can come out of a garden are gifts for other people. (Jamie Jobb)

This book puts forth a hermeneutic phenomenological method as a framework for art therapy supervision. Key aspects of supervision are addressed: the principles and goals, different models and techniques, the state of mind and attitude of the supervisor, awareness of culture, transference and counter transference dynamics, the supervisee supervisor relationship and the challenges that can emerge. There are some theoretical components that I am assuming the reader has had at least an orientation to. I am assuming that the reader has an understanding of psychoanalysis, object relations theory, clinical issues and therapeutic skills. Central to the guide are the unique aspects of art therapy supervision, which include looking at the client's art and art making activities.

Most of the time I will use the term supervisee rather than student intern, trainee or therapist because many of the same principles apply whether an individual is in the beginning phases of supervision or a working professional. The differences will be discussed with regards to the developmental process of supervision. I will also often refer to the client as the artist/client because I want to emphasize that everyone that engages in the creative process is an artist and that the identity of the client can be dignified by the seriousness of personal expression of an artist. In fact, in many of the successful outcomes of art therapy, clients emerge as artists in their own right. Art making and the creative process become a means of making meaning, of self-expression, of pleasure and a tool in self-understanding.

There are many valuable metaphors for the process of supervision and with my current awareness of the importance of developing our ecological

identity in combination with the journey or traveling metaphor I use nature and gardening metaphors throughout the book. Supervision is kindred to my love of gardening with the digging in the soil, excitement of planting seeds and plants, tending them, giving them room to grow, watering, watching and enjoying or giving away the fruits of the garden. The hard work of weeding, pruning, staking, raking and just sitting and being in the garden speaks metaphorically to all the aspects of supervision that I enjoy. Even when sometimes there is lots of digging and one needs to nourish the soil with more manure, or it needs weeding as there is not enough room for the plants that one would like to see flourish.

When I started writing with the metaphor of gardening I realized that I was always holding the perspective of the gardener creating a garden; the supervisor. In wanting to write from the perspective of supervisee, I found that I needed to look at other metaphors to truly speak to the experience of a learning supervisee. The metaphor of a journey seemed more inclusive of the different positions as well as capturing the sense of exploring new territory, discovering the not yet seen, and seeing new sights. This is a good example of working metaphorically and pushing the metaphor until it shows us the need to transform symbolically as well. So while I have restructured the book as a 'Traveler's Guide to Art Therapy Supervision' there are still many ecological and gardening metaphors throughout as in reality on a journey we do stop to visit gardens and natural environments, as well as art galleries, museums and relatives – past and present. I have just learned a new word 'hormesis' which refers to a healthy or growth response biologically to stressors or toxins. Holding this metaphor in mind can be of value in therapeutic and supervision work.

As we start on this journey it is important to consider where the desire to do this work – to work as an art therapist – comes from. This is, I believe, fundamentally to be a desire to alleviate suffering and to free oneself and others from emotional pain and problematic patterns of behaviour. There is a desire to learn how to help, to finding out what constitutes help and a sincere wish to bring "through our work as art therapists (and the persons we are) more balance, love, joy and peace in the world" (letter from Jacqueline Fehlner, 2011). I, find for myself, that I have a desire, a need and a deep commitment to compassionate action.

1 PERCEPTION AND INSIGHT: METAPHORS AND MODELS

When one tugs at a single thing in nature, he finds it attached to the rest of the world. (John Muir)

This quote speaks to the interconnectedness of all things – the interdependence of our ecological identity – the connections and the way that learning occurs and the ways in which knowledge and understanding develop. The process of supervision is kind of like exploring nature and that whenever you focus on one particular aspect you will find that it is attached to another aspect and in fact, pretty soon the whole world has entered in.

There are a number of basic propositions that create the lens I see through, and thus make up the framework of this book. I will identify the theoretical underpinnings which I will consider in the context of art therapy supervision.

Supervision is about perception and about a meta-analysis. It is a language about language, therapy about therapy or art about art. The supervisor hears about both the client and the therapist/supervisee – the supervisee speaks of his/her experience. The supervisor holds a unique position, which has the possibility of more objectivity and an open-ended perceptual framework is important.

The word supervision suggests special perceptive qualities, clear sight and insight, a different and better vantage point. The word supervision comes from the Latin super "over" and videre "to see". Generally speaking, the aim of the therapeutic relationship and the supervisee relationship is to promote insight. 'Insight' refers to the intuitive understanding of the inner nature of situations or oneself. In the context of art therapy supervision,

insight is both externally directed towards the client and internally directed towards the supervisee (Bradley, 1997).

Psychoanalysis

First of all I hold an underlying psychoanalytic framework, with key concepts of the unconscious and consciousness, primary and secondary processes (including condensation & displacement), drive theory, the structure of the psyche, latent and manifest meanings, defense mechanisms, object relations, and transference. Object relations theory is based on a social view of the self and holds the belief that the need for relationships is central to the development of the individual. The psychoanalytic techniques of free association, symbolic interpretation, and the exploration of transference and counter transference are core components and will be discussed in later chapters specifically in relationship to supervision.

Early psychoanalytic training had two models: one was the control analysis, which supervised the clinical work, and the second was the training analysis, which was the analyst's own analysis. There have been long term disagreements over whether those roles should be separate or the same. The control analysis was to focus on instruction and the training analysis was to focus on personal therapy. Eventually both camps agreed that there was overlap and both aspects were needed. The Hungarian system of supervision (Balint, 1964) is a group approach to exploring counter transference issues. Therapists are encouraged to report freely and to 'free associate' - to their experience. In art therapy supervision there is a clear distinction between supervision and personal therapy and while supervision may be therapeutic it may identify areas to be explored in more personal depth in the context of therapy.

The psychoanalytic approach looks at the parallel process of client/ supervisee and supervisee/supervisor. It encourages supervisees to examine their own emotional responses and reactions to the client and art. It would include looking at the client's and supervisee's defense mechanisms and the possibilities of projective identification. It would also include transferences to the artwork and scapegoat transferences (Schaverien, 1992).

From a psychoanalytic point of view the main aim of the therapeutic relationship and the supervisory relationship is the development of insight. Insight into others minds needs to be accompanied by insight into oneself. The supervisory relationship needs to be mutually and unconditionally based on a love of uncovering the truth. Freud writes: "We must not forget

that the analytic relationship is based on a love of the truth – that is on a recognition of reality and that it precludes any kind of sham or deceit." (Freud, 1937, cited in Bradley, 1997, p. 48). This desire to know and to be known also contains the fear of being known, the fear that if one is known that one may be found to be unacceptable.

Social constructivist theory

A social constructivist perspective views the 'self' as socially constructed. Social constructivist theory and narrative therapy focus on how each of us has been created and constructed by the world we live in by the people and environments in our lives and that we have created the world in which we live. Of particular interest is the way we use words (language) and how we interpret the events of our lives, both in the present and in the past and then how we connect these events sequentially in a narrative, thus creating meaning, which informs how we live our lives. (Riley, 1999) The basic concept of social construction posits that the social world and indeed our whole idea of the nature of the world has been, and is, socially constructed via metaphors or symbols. These symbolic constructions organize and guide behaviour. As such, all aspects of the social world, including the self, all social institutions, including those of religion and therapy only appear to be fixed or "natural." In fact, they are malleable and very changeable as can easily be seen in any cross-cultural study of social institutions. The social construction of the development of the self takes place over a great number of years in the context of social forms and other people. In order to become a person in society we must learn the language, learn how to behave in different situations, learn how to be a "good" person (or not), learn how to work and to play, take on our identity (with regard to gender, ethnicity, sexual preference etc.) and take on a role or, actually, many roles.

Art therapy and supervision can go through a process of deconstruction and reconstruction. In an exploration through art or in dialogue there can be an underlying question as to whether something that is hidden is being revealed or is a hidden potentiality being created. There is a spectrum of possibilities. We may discover something that we were not conscious of or had forgotten or not considered in that light. Considerations of meaning constructed in the therapeutic session pertain also to the supervisory session.

Language and metaphor

The 'self' is constructed in relationship to others and through language and metaphor. Metaphor is a way that we symbolically come to understand what is unknown through what is known or more familiar. In many ways one can view the self as being constituted by metaphor and the process of art therapy provides an opportunity to explore many metaphors of the self, maps of the self, in fact the whole creative process is a way of reconstructing the self.

In terms of language there is the language of art, the language that the artist/client uses in session, the language that the supervisee uses to describe the session, which may be different in the notes from what is described in supervision, and the language that the supervisor uses. From a social constructivist perspective the supervisor would attend to the use of language to construct the meaning of session, the art work and the artist/client. The supervisor will pay particular attention to the language used to interpret the events of the client's life, both in the past and the present, and how these events are connected constructing and creating meaning (Carpendale, 2009).

Metaphor involves the cognitive and emotional grasping of a more or less unknown concept or idea in terms of another better-known concept or idea. It is a way that we symbolically come to understand what is unknown through what is known or more familiar. For example a defense mechanism can metaphorically be seen as like a burl on a tree grown thicker in an area to protect the tree where it has been injured. It makes it more difficult for it to be reinjured at the same spot.

A combined language and art approach involves staying with the metaphor and exploring it fully in relation to the art, the client and the supervisee. New insights may emerge by putting things in a new perspective or introducing a new metaphor. Supervision can focus on metaphors that the supervisee and the client use. This method is particularly appropriate for art therapy supervision as the use of art making tends to promote the development of metaphor and symbol formation.

Metaphors can explore the unconscious, by pass defenses and shatter old paradigms. They can operate at a depth where opposite truths may be paradoxically valid, change perceptions of events and interpretations of experiences. For example an image can hold the ambivalent feelings of both love and anger towards an individual. Forming images and exploring

metaphors can give direction and insight into rambling thoughts and feelings.

In supervision the meaning of the artwork and the process of a session is explored in dialogue with the supervisor and we may discover something that we were not conscious of, had forgotten or not considered in that light. We may create something new in either the art making process or in the dialogue looking at the art. When this occurs in the therapeutic session it may be considered as a co-creation of meaning. In essence, the world and the self are not there to be discovered but are actually to be created. We create new worlds in each of the relationships we are involved with and we do this in dialogue, in language and in art.

During the art making process the artist/client can become aware of the symbolic and metaphoric process by the expression of understanding of his or her internal predicament which is seen in the context of our understanding of the human condition. Art therapy focuses on the making of models in the form of metaphor, which can reflect, and function in the dynamics of change. During the art making process awareness emerges regarding the metaphors we use for ourselves to express our life situation and the human condition. In the therapeutic process, one can creatively explore alternative metaphoric models which can then function to reconnect the psyche and the body, personality and community, the mental and emotional life and so on.

It is important to explore the artist /client's beliefs regarding the reason for therapy and his or her view of healing. Metaphors for therapy or healing could be focused on.

Metaphors interconnect the basic elements of human nature. Using images and words creatively can help to reconnect the psyche and the body. For example a woman in art therapy painted a crow flying over water. One of the crow's wings was smaller and more awkward than the other. When the painting was put up and looked at, the woman was surprised by the difference in the wings and upon self-reflection revealed that she had had surgery for a slow growing benign cyst on her brain which had to be removed some years previously. A result of the surgery was that she had to change from being right handed to being left-handed, thus the significance of the awkward left wing of the crow in the painting.

The process of describing a piece of art will reveal the individual's metaphorical language and his or her individual combination of symbolic and social constructions. I think that part of the mystification of art

therapy may have to do with the avoidance of looking at language and how we construct our reality via language.

It is important to remember that just as with interpretation the making of metaphors reveals certain realities and understandings and obscures others. Thus, the "unconscious" may be understood as a symbol-making container whereby events, feelings and ideas, which are not admissible to consciousness, manifest in a disguised form. In one sense, then, art therapy involves the uncovering of the unconscious roots of certain metaphors (i.e. those found in dreams or art) and through the interpretive process transforming them into other metaphors and/or linking them up into a congruent pattern of understanding which takes account of both past realities and present needs. Uncovering is one metaphor where we can think about how things are covered up and how they get uncovered. For example, it could be a blanket, dirt, or snow. The idea of roots pertains to a plant or tree as a metaphor. The use of the word 'trigger' refers to a gun, weapon or tool metaphor. Even having a new sheet of paper can be a metaphor to have a new experience of self.

I consider the art products that are made in art therapy sessions to be essentially a metaphoric vocabulary and to be considered as "language" standing on their own. Thus the visual and plastic forms are similar to the "text" of a speech. Art therapy can function to construct new identity or reconstruct pre existing identity that has been weakened or is in need of change through the creative act.

In the context of art therapy, the self interpretation of the artist's work takes place in conjunction with the art therapist who functions as a witness. In supervision the meaning emerges in dialogue between the supervisee and the supervisor – it is constructed in language. The supervisor is attending to the verbal and non-verbal communications of the supervisee, listening to the language and metaphors used, reflecting on the narratives, the artwork and the silences. The supervisor is attentive to his or her internal responses and encourages the supervisee to reflect on both internal and external responses.

An example of the value of looking at language and linguistics is in a lovely little book entitled Design Language where McCreight (1996) defined 'fragment' as

> 1. a part broken off or detached from the whole; 2. something incomplete; an odd bit or piece; 3. to break up into fragments, fragmentize....In order for an object to be

perceived as a fragment there must be a clear sense of a whole. This can be a learned association; most people can identify a fragment of broken crockery because of previous familiarity with intact cups and bowls. Fragment implies a passage of time. ... then it was whole and now it is in pieces.

The implications in terms of art therapy pertain to how we might view an image that is fragmented or an individual that speaks of feeling fragmented. We need to be aware of the relationship of the fragment to the whole with regards to the feelings and experience of the artist/client.

Phenomenological

Phenomenological concepts and methodology can be applied to all aspects of art therapy and supervision. Phenomenological methods can provide a theoretical framework for exploring the essential meaning or meaningfulness of the clinical experience as it is presented in supervision. In a phenomenological approach to art therapy the specific phenomena of creating artwork can be studied consciously as an immediate experience (Betensky, 1995).

Applying phenomenological attentiveness to the creative process of self-expression can lead to the possibility of self-discovery and insight. In terms of phenomenological art therapy practice I draw from both Mala Betensky and Judith Siano. I have extended their work into the area of art therapy supervision. In the process I draw from hermeneutic theory and a number of phenomenologists, in particular Gadamer, Merleau-Ponty, and Van Manen. A phenomenological exploration of meaning is always tentative always incomplete- never would a human lived experience be "presumed to be universal or shared by all humans irrespective of time, culture, gender, or other circumstance." (Van Manen, 2002)

Phenomenology is the study of essences: the essence of perception and the essence of consciousness, which makes it a very appropriate philosophical method to apply to the process of art therapy supervision. (Carpendale, 2003, 2009) This exploration of meaning and essence includes looking at the art, witnessing the supervisee's "lived-through" experience of the session and client, and attending to the "lived-through" experience of supervisee and supervisor in the supervision session. Supervision can also include post-session art and art making done in the context of supervision.

Psycho-cybernetics

Psycho-cybernetics introduces a systems model to supervision. Ideas about input and output and positive and negative feedback loops come into play. Paradoxical strategies might be utilized. Each part of the process would be looked at in relationship to the whole and in terms of the interplay of interpersonal dynamics. Input or insight into the artwork or the therapeutic dynamics creates an internal shift in the supervisee and it is quite surprising how that almost imperceptible new awareness creates a change in the potential space and the artist/client's therapeutic work. Similarly resistance in the supervisee can block the flow in the therapeutic or supervisory work. Cybernetics considers all aspects of the 'system' and the flow of information and insights (Nucho, 1987). The supervisor can facilitate the increase of flow with positive feedback loops and decrease the flow with negative feedback loops.

Experiential

Experiential supervision methods can be used with a number of different models. Interpersonal process groups may focus on experiential learning, role-play, dramatic enactment, and art making. The homily appropriate to this model is 'Tell me what to do and I'll forget; show me what to do and I'll remember; let me do it and I will learn." An art therapy studio course that has interns working together in triads provides an excellent opportunity for constructive feedback. In fact, many of the approaches to therapy or supervision can be enhanced through experiential learning. Working in triads, with a student intern using their own artwork in the role of the client, with a fellow student in the role of the therapist and one as an observer allows students to develop skills in recognizing good therapeutic skills and areas to be further developed.

Humanistic

A humanistic approach to supervision emphasizes the client and therapist's capacity for self-regulation, self-direction and self-determination. This approach would include an emphasis on the supervisee's feelings and his or her unconscious emotional response to the client. The supervisor utilizing this approach would respectfully reflect back the supervisee's observations and concerns. Empathy training can be an important aspect

that enables the supervisee to identify with the client while remaining separate. Empathy, acceptance and congruence would be integral to the supervisor's attitude and presence in the supervision session. Supervision can enhance the way that supervisee can use his or her own human experience as a source of knowledge.

Clinical

A clinical supervision model focuses on more didactic and cognitive modes of learning that are concerned with conscious thought processes and includes teaching theory and techniques. This includes the case presentation, client histories, assessment data, intervention strategies, ethics, clinical observations and record keeping.

Developmental

A developmental model to supervision takes into consideration the stage of the supervisees' learning and may be combined with any of the before mentioned methods. It may include actual instruction, group process, free association, transference dynamics, experiential work and case presentation. A developmental model would also focus on examining the client's issues in the light of developmental theory and object relations. This model will be discussed in terms of the different stages of supervision: beginning, middle and closing.

Summary

Supervision is central to development and training as an art therapist. It is the place where theory and practice mirror and reflect each other. In fact, supervision looks at every aspect of art therapy and functions essentially on a spectrum between therapy, research and education. The goals of supervision are not the same goals as therapy because one of the goals for supervision is to sort out the goals for therapy. Supervision is the place where the supervisee comes to discuss his or her clinical experience. The process of supervision includes learning to see things from the client's as well as the supervisee's point of view. It can come in a number of formats from individual, to group supervision, to online supervision (email & phone). Supervision includes the planning of sessions, the reflection on the

art therapy process, looking at the art, exploring interpersonal dynamics and transference.

These are a number of different models and orientations that can be incorporated into the context of a hermeneutic phenomenological approach to supervision, which will be discussed in depth in the next chapter. Supervisors may incorporate a number of these components and some focus entirely from a single specific approach. While supervisors may have a primary style due to the varying nature of supervisees' learning styles an experienced supervisor will likely utilize a variety of approaches.

2 A Silk Map: Hermeneutic Phenomenology

Supervision is an art form taking place within a professional relationship. (Robbins, 2007, p. 153)

This chapter outlines a basic theoretical framework and discusses the key concepts of hermeneutic phenomenology in relationship to art therapy focusing particularly on providing a foundation for the training and supervision of art therapists. The theoretical basis of this chapter has been previously published (Carpendale, 2003, 2009) but is extended here in the context of art therapy supervision.

Hermeneutic phenomenology can be applied to all aspects of art therapy: the materials, creative process, the client/artist, therapist and supervisory relationships. Hermeneutic phenomenology as a methodology is reflective of both terms. In being attentive to how things appear and wanting to let things speak for themselves, it is a descriptive phenomenology and it is an interpretive (hermeneutic) methodology in that all phenomena that presents as 'lived experience' is already captured in language and already meaningful and therefore interpreted (Van Manen, 1990). In the context of supervision the 'lived experience' should be considered on a number of levels. First of all there is the 'lived experience' of the client in his or her life – and there is the description, expression (in art) or narration of that experience; second of all there is the 'lived experience' of the client and the supervisee (intern/therapist) in the session together; and thirdly there is the 'lived experience' of the supervisee as well as the supervisor, in the supervision session. Clearly, there are potentially many more 'lived experiences' that may be relevant.

Hermeneutics is essentially the theory and practice of interpretation with the aim of understanding the writer or artist as well as or better

than the individual understands him or herself. In the case of art therapy supervision the focus of understanding is on both the artist/client and the therapist/supervisee.

Hermeneutics as a methodology for social sciences developed initially from the philosopher Schleiermacher through Dilthey (Messer, Sass, Woolfolk, 1988). It was Schleiermacher in his working on the interpretation of ancient texts, who found that the typical methods of interpretation did not lead to a deeper understanding of the structure of literature from prior periods. He felt that it was important to consider the socio-cultural context and any particular factor that might influence or affect the writer researcher in the exploration of meaning. The focus on understanding the original intentions of the author became the basis for valid textual interpretation (Messer, Sass, Woolfolk, 1988). According to Schleiermacher, hermeneutics is necessary when there is the possibility of misunderstanding (Van Manen, 1990, p. 179).

In art therapy, interpretation is aimed at eliciting and exploring the meaning emerging for the artist/client. The underlying premise for art therapy interpretation is that it is the artist/client who interprets his or her own artwork and the interpretation occurs in dialogue with the art therapist as witness. In art therapy supervision hermeneutics focuses on understanding not only the artist/client but also the supervisee/therapist.

In a hermeneutic methodology the process of interpretation acts upon the 'text', which is the focus of interpretation and may also act upon the individual who is interpreting. In the context of art therapy supervision the 'text' can be considered or refer to a number of potential aspects: the personal history of the client, the presenting problem, the clinical session, the artwork and the process of creating the artwork; the dialogue in session; the notes take after session; and the dialogue in supervision.

Van Manen describes the hermeneutic emphasis for Dilthey as not being the fundamental thought of the other person but the world itself, the 'lived experience,' which is expressed by the author's text. Dilthey's hermeneutic formula is 'lived experience': the starting point and focus of human science; expression: the text or artifact as objectification of 'lived experience'; and understanding: not a cognitive act but the moment when "life understands itself" (Van Manen, 1990. p. 180).

This emphasis on the importance of the 'lived experience' as expressed by the individual's text or artifact is fundamental to the practice of art therapy. The focus on "life understanding itself" and the emergence of meaning for the individual in relationship to the world is a core therapeutic

component. Creating art in a therapeutic context provides an immediate 'lived experience' to be explored, which includes not only the thoughts of the artist/client but also their physical, sensory and emotional experience. Both the artwork and the creative process can be considered as a text for exploring meaning. (Betensky, 1995, Carpendale, 2003, 2009)

Heidegger's hermeneutics is considered an interpretive phenomenology. For Heidegger the focus of hermeneutic understanding is not simply to try and understand what the author of the text intended to communicate but he realized that the process of interpreting a text opened up the possibility of the interpreter being revealed by the text (Van Manen, 1990, p. 180). This is very much true in art therapy. The process of exploring the meaning in the artwork and the creative process opens up the possibility of insight and understanding to be both discovered and created in the dialogue between the artist/client and the art therapist.

Supervisees come to supervision to gain more understanding and there is the desire for knowledge and to be known and recognized – and there is equally the fears that one will have done wrong, made a mistake and will be found wanting or unacceptable. The supervision process is a process of self discovery.

This possibility of being revealed by the text is both fearful and exciting. Artist/clients come in to therapy to gain more self understanding. There is the desire to know and to be known as well as the fear that if one is truly known that one will not be found to be acceptable. There can be the lurking fear that one is too bad or too messed up to be loved. It is equally important for the therapist (student/supervisee) to approach the therapeutic encounter and dialogue with the awareness that he or she may also be revealed. In fact, many of the concerns brought into supervision pertain to the therapist/supervisee being unaware of or reluctant to look at the meaning being revealed not only for the artist/client but also for themselves.

Gadamer's (1975) position regarding interpretation is that we can never separate ourselves from the meaning of a "text". It is my intention to include, not only writing in the term "text," but also the artwork, the physical body, life narrative's, human action, situation and all of lived experience (Ricouer, 1976, Van Manen, 1990, p. 180). Applying this idea to art therapy one would say that the therapist is an integral part of the therapeutic experience and the very nature of the questions posed, responses reflected and meaning that emerges in the dialogue is as much a part of the art therapist as the artist/client. The art therapist's belief that

meaning and essence will emerge and the seriousness of the endeavour contributes to the experience of artist/client.

Hermeneutic Circle

The hermeneutic circle is a term used to describe the manner in which, understanding emerges and refers to the contextual nature of knowledge. Even within considering the meaning of a sentence each of the words will have individual meanings but those meanings will only clearly emerge in relationship to the other words. The parts are seen in relation to the whole and the context of the whole gives meaning to the parts. The same is true with looking at artwork and with looking at the narrative of an individual's life. Thus this awareness of the relativity of meaning and the process in which meaning will emerge is integral to the development of an art therapist. The hermeneutic circle refers to how in interpretation one cannot escape references to what is already known thus understanding will emerge in a circular manner moving from the relationship of parts to the whole and back to the parts. (Messer, Sass, Woolfolk, 1988) And all of these aspects are in relationship to the viewer / writer / researcher. This philosophic approach to interpretation has been applied to texts and to art. It does not mean that one can never understand a piece of art but it does mean that one can never completely understand a work of art or rather that there will always be the possibility of more meaning to be discovered. This articulation of the process of how understanding and meaning can emerge relates to the art therapy process. Understanding and interpreting a work of art in therapy is an ongoing process, which takes time. As the therapeutic relationship deepens and more insight and personal history emerges interpretation of the creative process and the artwork gradually evolves and changes.

This circular pattern of interpretation is also referred to as a "hermeneutic spiral" because it moves from the parts to the whole and from the whole to the parts forever. The circular exploration in art therapy pertains to not only looking at the text or artwork in this manner but it also explores the relationships. In art therapy these relationships are between the client and the artwork, the client and the therapist, the therapist and the artwork, the supervisee and the supervisor. One only slowly approaches the truth of the situation and the truth will change as the contexts change.

The principles of phenomenological hermeneutics (Lye, 1996) can provide an interpretive framework to examine the concrete nature of the

art materials, the creative process and include psychological and clinical theory. A phenomenological exploration of meaning is always tentative always incomplete - never would a human lived experience be "presumed to be universal or shared by all humans irrespective of time, culture, gender, or other circumstance" (Van Manen, 2002). The attitude of the phenomenologist can be of value for an art therapist. It is important to stay open to new meanings being revealed, to never impose an interpretation as fact, but to use interpretation to shed light and provide the possibility of understanding and the development of new meanings.

Vocatio

The term "vocative" derives from vocare, to call; and from the root "voice". It means to address, to bring to speech.

The aim of the vocatio is to let things "speak" or be "heard" by bringing them into nearness through the vocative power of language....

The vocatio has to do with the recognition that a text can "speak" to us, that we may know ourselves addressed by it.

The more vocative a text, the more strongly the meaning is embedded within it, hence the more difficult to paraphrase or summarize the text and the phenomenological understandings embedded within it.

The voking act provides the possibility to "know one's self", not in the narrow sense of narcissistic self-examination but in the sense of discovering existential possibilities, what it is to be human, what lies at the heart of our being and personal identity. The "call" signifies that we need other selves, others, the Other, through whom and with whom we seek understanding. (Van Manen, 2011)

This need for others to reflect our sense of self is a key component in the therapeutic relationship. We have an implicit, felt or 'pathic' understanding of ourselves in situations even though it is difficult to put that understanding into words (Van Manen, 2002).

In art therapy the artwork is to be considered as a text, and as such it can "speak" to us. Using the vocative method in phenomenology refers to approaching the text with the concept of both listening to the text and speaking to the text and when we are approaching the artwork as 'text' we need to be open to both address and to be addressed by

the art (Van Manen, 2011). There is a tendency when we speak to the artwork or about the artwork to stop listening to the object or artwork of which we speak. The artwork can only speak if we listen to it and are open to being addressed by it. This means that we will not already know what it will give voice to. This is a very significant component of the phenomenologist's attitude that needs to be brought into the art therapy session and into art therapy supervision. The artist/client may be speaking about the artwork and the meaning they have attributed to it with a long narrative but may become more anxious to be asked to look at the art to see what is there. Likewise the supervisee may come into supervision with the intent of telling the supervisor what happened in the session as if it were fact and not their own interpretation of the session. Looking at the art in supervision or creating art in supervision may often serve to bring the artist/client into more current awareness.

Art and perception are integrally linked. Creating art is a direct experience. Looking at art and becoming conscious of it is another direct experience (Betensky, 1995). The art therapist needs to suspend a priori judgments about what should or should not be seen. They need to look with openness and to look with intention – to see, to perceive. Betensky (1995) quotes Kant, "Inner perception is impossible without outer perception." Through the process of looking at the created artwork in art therapy the artist/ client learns to see all that can be seen. The structure, dynamics and meaning in the artwork can be explored through first of all a description in detail of the artwork and then connecting the metaphors to their inner experience and associations (Betensky, 1995).

As an object of study, the therapeutic modality of art therapy actually has the advantage of offering an intense 'lived experience' - the creative process - and the possibility of reflecting upon this intense lived experience through entering into a dialogue with the artist/client regarding the artwork created. The creative process in art therapy can take an individual through sensory and kinesthetic expression to perceptual and affective awareness on to cognitive and symbolic meaning (Lusebrink, 1990).

The phenomenological method fosters an attentive sense of wonder in the world and hermeneutic practice continually aims at open-ended interpretation, the recognition of bias, and the relating of part to whole and whole to part.

The Phenomenological Method

Phenomenology is a philosophical method aimed at getting at the truth - it aims to achieve clarity of insight and thought while including the subject. It makes a distinction between appearance and essence. Phenomenology focuses on the study of essences: one is always looking for the essential nature or meaning of the phenomena. In philosophy it is used to focus on the individual's conscious, perceptual and intellectual processes, excluding preconceptions and the idea of external consequences (Gregory, 1987). It is a very appropriate philosophical method to apply to the theory and practice of art therapy. (Carpendale, 2003, 2009) Merleau-Ponty, the French philosopher, writes that "Philosophy is not the reflection of a pre-existing truth, but, like art, the act of bringing truth into being." (1969, p. 29)

"Phenomenology offers an answer to a long needed unbiased approach to art therapy in all its spheres: theory, training, and professional practice." (Betensky 1995, p. 13) She articulates the importance of 'seeing' and suggests that "perhaps this is one of art therapy's most important contributions to general therapy and even to phenomenology itself, because art therapy pays attention to the authentic experience in a twofold way." (1995, p. 5) She emphasizes the two direct experiences – one of creating the art and the second of looking at the art – and the perceptual engagement – which requires the support of the therapist in learning "how to look in order to see all that can be seen in their art expression" (Betensky, 1995, p. 6).

Merleau-Ponty wrote "to look at an object is to inhabit it and from this habitation to grasp all things." He continues in stating:

> The world is not problematical. The problem lies in our own inability to see what is there. The attitude of the phenomenologist, therefore, is not the attitude of the technician, with a bag of tools and methods, anxious to repair a poorly operating machine. Nor is it the attitude of the social planner, who has at his control the methods for straightening out the problems of social existence. Rather it is an attitude of wonder, of quiet inquisitive respect as one attempts to meet the world, to open a dialogue, to put himself in a position where the world will disclose itself to him in all its mystery and complexity (1969, p.12).

Part of the art therapy experience is reflecting on the lived-throughness. Lived-throughness is brought into the art therapy session by both creating art and bringing the narrative of past experience into the present. The lived-throughness of the creative process, which may through speaking of it produce a 'text', and the lived-throughness of the subject matter or content of the artwork, which may pertain to past experience and feelings, which are present in the individual.

In therapy one has to stay aware of oneself as the therapist – that one exists and are perceiving the subject and that any analysis needs to include the first sensations and aspects of the object/subject from different perspectives (we need to figuratively walk around and get a good look to get a good description. Merleau-Ponty tells us that, "the real has to be described, not constructed or formed" (1969, p. 17).

Phenomenological art therapy as explicated by Dr. Mala Betensky (1995) is a clearly formulated art therapy approach that attempts to understand the phenomena of the artwork and the creative process from within itself through "intentional observation" and reflection.

The word 'phenomena' comes from the Greek meaning 'to appear' and refers to all that can be perceived and observed with our senses and our minds, including mental and physical experiences; visible, touchable, audible things in the worlds as well as thoughts, feelings, dreams, memories, fantasies. The use of phenomenology is to investigate the fullness of subjective experiencing of things. The three main features of the phenomenological method are 1) the attention to the description of the perceived phenomena; 2) focus on capturing the essence; and 3) the essence is found by intuiting and not by deduction or induction. The five key concepts of phenomenology concepts outlined by Merleau–Ponty in the introduction of Phenomenology of Religion (Bettis, 1969) can be applied to art therapy (Carpendale, 2002, 2009). These concepts are: description, reduction, essence, intentionality and world.

Before I relate these concepts to art therapy supervision I would like to speak briefly to the nature of this method. First of all, it is not a sequential process and does not have to follow a specific method - these five conceptual elements do not need to appear in any particular sequence, nor do they appear one at a time. Rather, they can overlap and interpenetrate one another much like a weaving. I tend to view these concepts in terms of a figure / ground relationship – thus when we bring one element into focus, it always appears against or as the ground of all the others. Thus when we speak of one, such as intentionality, we are also speaking of the

other four elements in context. These aspects can be related directly to art therapy and art therapy supervision.

Description

Phenomena are studied as they present themselves in consciousness as immediate experience. In the context of art therapy the artwork is to be considered as a 'phenomena' with its own structure, dynamics and meaning. The creating of the artwork is also a phenomena and the dialogue about the art either during or subsequent to the creating is also a phenomena. The artist/client, the art studio environment, potentially other group members if in a group, and the art therapist are all each individually a phenomena and the whole experience is a phenomena. In the context of art therapy supervision, the supervisee's experience is also a phenomena, which includes internal reflections and external behaviour, record keeping, caring for the artwork, preparation and presentation in supervision.

The description of the 'lived experience' and the 'text' is not intended to be a scientific description, explanation or analysis. Specifically, in this step we are looking for a pure description, not analytical reflection and not scientific explanation, and not tracing back to inner dynamics. The description will include the concrete and tangible but it is important to remember that all language is metaphorical in nature and that it is through metaphor that we come to understand the unknown by relating it to what is known. Focusing on the description can be of great value because sometimes the intent to explain loses the essence of the experience. It may be more metaphoric or poetic in the attempt to describe what presents itself to consciousness.

Just as through the process of looking at the artwork and describing it the individual client learns over time to see a great deal more than they saw when involved in the creative process, so does the supervisee learn to see more by describing the artwork and the process of the session. The verbal description is an essential part of the supervision process. The process of a detailed description will reveal metaphors that can enable the supervisee to connect to an inner experience. The intention in this process is to make a verbal translation through a description of the visual and not to explain, analyze or be seduced into a narrative. It is a return to the image, the creative process and the concrete nature of the artwork, the artist/client and the session. The intent with this step is to look in order to see what is there.

The therapeutic process is about learning to look and to perceive. We can find the actual detailed world here and thus ultimately the essence.

In art therapy supervision what is called for is a clear description of the client, the therapist, the artwork and creative process. I repeat myself in stating that this is not an explanation. Explanations and the scientific method move past the immediate experiential data to models or laws of nature, which then control the data. While the scientific method and explanations are useful they can lose sight of the original data if one gets too involved in explaining. "Reductionism identifies the scientifically observable causes of an event with the meaning or significance of the event." (Merleau-Ponty, 1969. p. 6) Data, which can't be quantified, is dismissed as subjective. The personal meaning of an event may be different than the scientific meaning of an event. In the description one wants to get away from assumptions and interpretations. If you really look and describe what you see you will already be 'bracketing out' your assumptions.

The Reduction (or bracketing out assumptions)

The significance of the reduction (bracketing) is the idea that we are looking to re-achieve a direct contact with the world as we experience it rather than how we conceptualize it. The intent of the reduction is to come to understand the essential nature or structure of something or other, and in order to do so we need to reflect on it and bracket out our assumptions. This process is intended to bring the aspects of meaning that belong to the lived world into focus. Reduction as a method is more a way of being than an act itself. It is the bringing in of a thoughtful attentiveness. The art therapist can benefit from the phenomenologist's attitude of curiousity, open-mindedness, wonder and attentiveness. Max van Manen (2002) writes that

> The aim of the reductio (the reduction or epoche) is to re-achieve direct contact with the world by suspending prejudgments, bracketing assumptions, deconstructing claims and restoring openness.

This concept has a variety of forms but the idea is simple. Therapeutically the first thing that one needs to bracket out is that there is a problem or at least a specifically defined problem. We want to put it aside for a moment and look to see exactly or hopefully more clearly what is happening. This involves bracketing out our assumptions, interpretations, transferences,

counter-transferences, goals, and biases to enable us to distill the essence. In fact, in some sense one is 'bracketing out' the whole "question of existence in order to devote attention to the question of meaning" (Merleau-Ponty, 1969, p. 8).

In order to bracket out the assumptions it is important to first of all, consider what they are. Assumptions are the often things that have been told the art therapist about the client – likely from the referral source, other professionals, parents and the client themselves. This can include the diagnosis, the therapist's theoretical approach, the client and/ or the parents' and the professionals' interpretation of the problem and the client's own assumptions about his or her state of being. Attention to the reduction may reveal potential health in other areas. For the supervisor it is important to bracket out the assumptions to see and hear what is actually being presented by the supervisee.

What may be useful here is to identify the assumptions. If one doesn't go through a process of naming one's prejudices, biases, conceits, demons, pitfalls, interpretations, beliefs, values, therapeutic goals, work pressures, they will inhabit the therapeutic space or rather lurk around it. This can happen especially when we experience difficulties or are concerned about how to proceed therapeutically. In fact, it may or may not be ourselves that are stuck it may be the client or vice versa because we are stuck on an interpretation.

There are several levels of the reduction that have been outlined by Max Van Manen (2002). The first one is to return to a sense of wonder regarding the object of interest and to bracket the attitude of taken-for-grantedness. This reduction leads us to a state of wonder and "wonder" is that moment "of being - when one is overcome by awe or perplexity - such as when something familiar has turned profoundly unfamiliar, when our gaze has been captured by the gaze of something staring back at us" (Van Manen, 2002). The physicality and sheer presence of an artwork can aid in the possibility of this kind of discovery. It provides an objective other that is also a part of the self because the self has created it.

The reduction is about putting aside one's subjective feelings, prejudices, bias and expectations. It is also about putting aside the clinical, psychodynamic or developmental theory that might come to mind. The intent of the reduction is to see with fresh eyes the actual lived experience not already defined and circumscribed by issues and themes. The eidetic reduction is about not being seduced by the intensity of vivid mental images and the narrative of the situation and being able to focus attention

on the essence of lived meaning. The eidetic technique of "variation in imagination" refers to a process of comparing the phenomenon in question with other related but different phenomenon. What makes this experience - this piece of art, this client, this situation or supervisee - unique and different from other lived experiences? This is where one is considering the relationship between the individual lived experience and the universal - iconic - essence - that does not pertain to the immediacy of the lived experience. This does not refer to a generalization of human nature or view of the collective unconscious. One is looking for an experience of meaningfulness.

The reduction is not the end of the method it is very much just part of the process of opening up to wonder and to an open ended attitude of curiousity in the mystery of existence. The philosophical ideas behind the reduction are kindred to the concepts underlying the teaching of therapeutic presence in art therapy. This practice of the phenomenological reduction is very valuable to the practice of culturally sensitive and responsive therapy and supervision.

Van Manen (2002) identifies the hermeneutic reduction as the aspect where we need to bracket all interpretation and attend to an attitude of openness. In order to seek openness one needs to reflect on the assumptions, and theoretical framework and biases that colour the viewpoint of the situation or problem issue. Part of this process is to become aware of the subjective feelings and pre-understandings that prevent us from having a "radical openness to the phenomenon" (van Manen, 2002). It is not possible to completely bracket out all the previous information and understanding so that what may be more important in this step in order to reach a critical self awareness is to express or give voice to these assumptions and concepts. In this process one is examining all of the aspects that cloud or restrict the reflective gaze. It is not that one is trying for the illusion of a pure perspective but that exploration of lived experience is considered with various layers of meaning.

The phenomenological reduction focuses on bracketing out concreteness, knowledge, abstraction, theorizing, generalization or all of what we would call 'real' or 'not real', in order for the living meaning to be revealed (Van Manen, 2002). The methodological reduction is the bracketing of one's particular approach, including all the usual "methods or techniques and seek or invent an approach that seems to fit most appropriately the ... topic under study" (Van Manen, 2002).

"The phenomenologist also brackets out the question of truth as "actually being the case" to expose the question of truth as "meaning" (Merleau-Ponty, 1969, p. 8).

The Essence

The term "essence" is derived from the Latin essentia, or esse, which means "to be" and from the Greek ousia which means the true being of a thing referring to the inner essential nature of a thing. Essence is the core of the phenomena - that makes it what it is - that aspect that would make it not be what it is. In phenomenology essence is referred to as 'whatness' of things, rather than the 'thatness' of things. The 'whatness' pertains to the essential being or nature whereas the 'thatness' refers to existence itself.

We want the experience of truth. "To seek the essence of perception is to declare that perception is not presumed true, but defined as access to truth" (Merleau-Ponty, 1969, p. 24). I look at and perceive a world and I have experiences of the real as well as the imaginary. "In this we are seeking meaning or essence rather than any specific cause or claim for objective truth - we must not wonder whether self-evident truths are real truths. The world is already there before reflection begins. "Looking for the world's essence is not looking for what it is as an idea once it has been reduced to a theme of discourse; it is looking for what it is as a fact for us, before any thematization." (Merleau-Ponty, 1969, p. 23).

In the phenomenological method there is a focus on distilling the essence. This will include exploring the meaning of the artwork, the creative process and the being of the client. What is the core of the problem? What is in the art? What is the essence of the individual? In art therapy supervision there is the continued process of questioning the art in order to discover meaning. We are certainly interested in essential meaning but also what the subsidiary meanings are and how they relate to the essence.

The intention of supervision is to seek the essence of the therapeutic experience. To learn from experience one must first have an experience and then become aware of it and then think reflectively about it. Art can be viewed as holding or mirroring the essence of the art therapy session and it survives the session as a material object. Images hold the possibility of simultaneity, which is impossible in discursive or verbal communication.

Looking at the art involves intentionality: looking to discover meaning to discover the essence. It is not the cause or factual truth of the matter that one is looking for but rather the exploration of meaning and an understanding of the essence.

Intentionality

The term "intentionality" refers to the interconnectedness of human beings to the world. It is a term rooted in medieval philosophy as being that aspect that distinguishes mental or psychical existence from physical existence (Merleau-Ponty, 1969). All consciousness is intentional in nature and in fact all thinking, which includes perceiving, imagining, and remembering, is always thinking about something. The same is true for actions, which are all intentional in that we listen to something or hold something or point at something. It is only with reflection that we are aware of intentionality because in an ordinary state of mind we experience the world as already made, already there. "All human activity is always oriented activity, directed by that which orients it." (Van Manen, 1990, p. 182)

It is important to remember that experiencing and reflecting are two separate activities and that we cannot experience something while we are reflecting on it. As soon as we start to analyze a feeling or experience we are no longer immersed in the experience of it. This occurs as one starts to look at the artwork in order to see what is to be seen. It is very important to remember that the creative process is different than the reflective or interpretive process, because as soon as you start reflecting or analyzing while creating the creative process is circumvented. For this reason it is important not to ask questions regarding the artwork or creative process while the individual artist/client is engaged in the work itself. This is because the questions and reflections will change the nature of the creative process itself. Now as soon as I state something like that with some degree of authority I am reminded of times when this is not true or appropriate in a therapeutic process. In fact, there are times with children or adolescents when they might be involved in some intense chaotic discharge and the approach of the "third hand" (Kramer, 2002) could bring the process into a formed expression which would be more ego-syntonic and lead to more grounding and a positive awareness.

Intentionality pertains to the meaning, the motivations and the desire of the client as well as the desire of the art therapist. The intention, the

motivation for therapy generally focuses on the discovery or creation of meaning in life for the individual. All mental activity is directed towards an object – you can't think without thinking about something. Feeling is not pure – it is always directed or about something. Therefore there is a unity of subject and object.

A phenomenologist looks in order to see - to see with intentionality. Intentionality suggests "bracketing" previous judgments or acquired ideas. When one is intent on what one is looking at; the object of attention begins to exist more than before; it becomes important, it means something to me. There is an intentionality of emotion in relation to the object and a new aspect emerges, which is 'meaning'.

The intention is not to problem solve specifically but to gain a deeper understanding, a glimpse at truth or the essential meaning of an experience. As we become more conscious as a therapist we will perceive the essence of the therapeutic relationship and be able to respond intentionally and not unconsciously.

World

We create the world and we exist in the world "the world is not something that exists prior to reflection. Prior to reflection there is lived existence, but this is an immediate and non-reflective spontaneity" (Merleau-Ponty, 1969, p. 11) the human subject is being in the world; being with others. The client can't be described or viewed in isolation. The artist/client is in the world – they have fellow group members, family, school, work, peers, therapist, and others. His or her social interests and interactions are in the external environment. This could also reflect the student/supervisee's role in the world.

There is an interesting paradox - we are always in context with others and we always have intentionality that pertains to someone or thing and as I write this I am aware that my intentionality is to communicate with art therapy students and other art therapists. So although we are always in relation to others, there is also the existential dilemma that we are essentially alone, we will all die alone.

Being in the world or context would include the artist client's personal history, significant life events: illness, social/ family changes, losses, trauma, family structure (family of origin & present family), culture, and developmental stages. What are all the related factors? Listen for the gaps in the narrative. It would also include the supervisee's context

and being-in-the-world. This might include transference or counter transference dynamics.

In supervision – the supervisor would explore how the artwork and the art making process got interpreted in the context of art therapy session. But how does this come to light? Insight occurs, as the client is involved in creating the art and when he or she enters into a dialogue with the therapist about their art. Art therapists have conscious or unconscious and more or less cohesive interpretive frameworks, which give direction to their questions, frame their clinical responses and set a tone for their reflections regarding the artwork. The problem is essentially, how to teach openness towards interpretation while communicating the need for restraint concerning certainty and the fact that interpretations do not necessarily need to be shared with clients.

How and where does the looking at the art occur? It happens in a number of places. First of all, the artist/client will be looking at the art while they are creating it, then they will look at the art with the art therapist. After the session the art therapist will look at the art and write notes and later the therapist will bring the art into supervision to look at the art with the supervisor. Finally, the supervisee/therapist will look at the artwork again with the artist/client in a subsequent session or as part of an art review done periodically in the context of the therapy or as a process of closing.

Why do we take the time to look at the art? Why do we write notes about the art?

To write is to draw us in through words. Phenomenology has been a philosophical method that has used writing as its mode of inquiry. Van Manen (2002) writes beautifully of the process of writing "A text, which is thoughtful, reflects on life while reflecting life. In thoughtful phenomenological texts, the distinction between poetic and narrative is hard to draw." He goes on to remind us that writing in a phenomenological inquiry is based on the idea that no text is ever perfect, no interpretation is ever complete, no explication of meaning is ever final, no insight is beyond challenge. It behooves us to remain as attentive as possible to the ways that all of us experience the world and to the infinite variety of possible human experiences and possible explications of those experiences.

Max Van Manen warns that

> To do hermeneutic phenomenology is to attempt to accomplish the impossible: to construct a full interpretive description of some aspect of the life-world, and yet to remain aware that lived life is always more complex than any explication of meaning can reveal. (1990, p. 18)

Summary

The hermeneutic phenomenological method applied to art therapy supervision considers both the art and art making as text and the clinical writing as text. It holds that meaning will continually emerge and that there will always be the possibility of new meanings. In many ways it is the attitude of the phenomenologist that we are trying to achieve in the supervision and training of art therapists. The ability to perceive and describe with openness and wonder, the ability to describe without explaining, judging or making assumptions, the ability to look with intention and to consider everything in context and relationship, and to intuitively distill the essence are all important therapeutic qualities. For an art therapist this method can be used in the therapeutic session, in the process of reflecting on the session through writing and art making and in supervision.

The intention of a hermeneutic approach to supervision is to keep awareness of multiple levels of interpretation and the process of moving from the whole to the parts and back to the whole can prevent premature closure on the analysis of clinical work. It speaks to the importance in supervision of developing a 'space for thinking'. The circular exploration moving from the whole to the parts and the parts to the whole it not only about looking at the text or art work in this manner but it also about the relationship or dialogue between the reader or viewer and the text or art work. Absolute knowledge is impossible and interpretations are always going to be incomplete or rather emerge in an evolving dialogue.

3 SHOES, BIKES, CARS, TRAINS, BUSES AND PLANES

The gift of supervision is the permission for the trainee to hypothesize, experiment, and fantasize creative moves both with the therapeutic plan and the art expression. (Wilson, Riley, and Wadeson, 1984, p. 103)

To start on a journey we need to consider what will be needed on our travels and prepare our back packs. What type of luggage will we use and what we will put in our luggage? All of this will depend on where we are traveling, the mode of transportation, and the destination. Let's consider what needs to be packed in our suitcase, like the underlying theoretical positions; and then what we will put in our day pack - how we will prepare for each supervision session.

The key functions of supervision are:
- To educate– sharing of knowledge by the supervisor
- To monitor the therapeutic work – to ensure safety and efficacy
- To enhance the theoretical understanding and integration of therapeutic skills.

There are three main focal points:
- The process and content of the client's concerns, personal dynamics and communications, including the artwork;
- The transference and counter transference reactions between client and therapist/supervisee;

- The supervisee and supervisor relationship which may be a mirror image of the client / therapist relationship. Sometimes a parallel process can be observed.

There are alternative perspectives on the goals of supervision:
- The supervisor is directing the case and the supervisee is functioning as an extension;
- The supervisee is functioning as the therapist and the supervisor is functioning as a consultant.

The first perspective is based on the belief that the supervisee doesn't know what to do and needs/wants to learn and the best way to teach is to tell them what to do. However, this can be problematic because there is no one right way to do art therapy and all the varying approaches emphasize the importance of creativity and flexibility in the therapist with authenticity and therapeutic presence being the most important ingredient for therapeutic change. Authenticity will only develop by encouraging the art therapy supervisee to be more themselves and not to have them try to duplicate what the supervisor might say or do. One can also look at supervision more developmentally, in that initially the supervisor may be more specifically directive and as the supervision progresses the supervisor emphasizes the supervisee coming up with his or her own creative and therapeutic interventions. The problem with this approach if it continues throughout the supervisory process is that it can create a dependency on the supervisor and doesn't encourage the supervisee to think on their feet and to trust their own responses.

The second perspective comes from a humanistic perspective and is based on the belief that if the supervisee has a good grasp of the theoretical issues underlying clinical work then he or she will with support be able to solve their own clinical dilemmas. One can foster this attitude by encouraging the discovery of alternative solutions. Again, this can be looked at in terms of a developmental model of supervision in that the second perspective is necessary as the supervisee moves into the middle and more final stages of supervision in a training program.

The Goals of Supervision

The goals of supervision have been summarized from a number of good references on supervision and art therapy supervision. (Lahad, 2000, Malchiodi, Riley, 1996, Schaverian & Case 2007, Shipton, 1997).

First and foremost the supervisor needs to be accountable to the clients:

- To focus on understanding the client issues and to ensure the issues and needs are understood, supported and appropriately responded to.
 - o The art is valuable to keep the client in view – unconscious material may be more evident. The questions the supervisor may ask about the art can heighten the supervisee's awareness of the process and facilitate distilling the essence.

- To protect the client through accountability and joint responsibility with colleagues develop strategies and make responsible judgments about treatment by developing strategies and make responsible judgments about treatment.
 - o Examining the art can help trainees learn to think about the process of therapy and identify appropriate art directives and directions.

- To improve client and therapist communication via looking at the art. The supervisor may try to bring to light more of the clients' views and communication.

- To monitor the supervisee's work to ensure its safety, efficacy, and consistency with policy. In the context of supervision it is important to examine ethics, laws, documentation and the rights and welfare of clients.

- To set boundaries and safe limits means that the supervisor needs to be accountable to the clients as well as the supervisee, which can include intervening or setting limits to the supervisees' engagement in the clinical process.

Secondly, the supervisor needs to be accountable to the supervisee:

- To reduce the anxiety of the supervisee

- To encourage free associative thought, and a capacity for self-awareness and creative reflection.

- To reflect and enhance the supervisee's skills

- To develop flexible thinking and the ability to think on your feet and be responsive to a therapeutic situation:
 o To devise successful therapeutic strategies,
 o To develop creative new approaches to clinical problems,
 o To create a space for problem solving,
 o To learn therapeutic strategies and techniques,

- To increase skills in looking at and exploring the art,

- To suggest intervention strategies for treatment,

- To examine both problems and successes.

- To meet the educational needs of the supervisee and to encourage students to stay contemporary in their learning.

- Augment resources and learn from research

- To examine inter-dynamics of clients, colleagues and fellow students including the student's relationship with the supervisor;
 o To enhance and clarify communication skills
 o To learn from experience and to clarify feelings;
 o To explore transference and counter transference dynamics;

- To explore theory in relation to practice in a wide range of clinical and agency settings;

- To develop a professional identity as an art therapist.

Types and Styles of Supervision

Supervisors may have different styles and will have different levels of a hierarchical relationship and might use a different approach depending on the issue presented or the supervisee's needs and learning style.

There are different types of supervisor / supervisee relationships:
- Clinician – on site, direct contact, focuses on clinical skills and case management
- Instructor –supervisees through classroom activities, focuses on learning conceptual practical skills
- Peer sharing and supervision
- Consultant- on specific areas of knowledge
- Mentor
- Facilitator of groups and discussion
- Art therapy supervisor: an art therapist may provide any or all of the above, plus, they also will include looking at the client's art and creative methods of exploring supervision concerns.

Lidmila (1997) outlines 4 different modes of supervision: the detective, the inquisitor, the librarian and the explorer. While the value of an exploratory approach is evident, it is easy to see how supervisors may slide into the other modes. A detective or sleuthing mode tends to focus on slips of the tongue, parapraxes, mistakes, jokes, and denials. The intent is to explore the text, the narrative and "crack" the case. Lidmila writes:

> Psychotherapists, rather like a gumshoe, suffer, or perhaps enjoy, an anal preoccupation with dirt, with getting to the bottom of things and much of what we understand as psychotherapeutic technique is a version of playing with discourse, analyzing, code breaking, sign reading, deconstructing and finally refusing to become a character in someone else's text (1997, p. 42).

One is looking for the moment when the text becomes transparent. Waiting with free-floating attention is like a stakeout in a detective case. One must consider all of the most unlikely and unimaginable things or possibilities. One must hold lightly the structure or the presented dynamics

and be prepared for the surprise - the anomaly. Both the therapist and the detective must not fall in love in the scenario. (Lidmila, 1997)

The inquisitorial mode can easily become persecutory. The supervisor may appear to interrogate rather than listen in an encouraging and responsive manner. The librarian mode tends to focus on a quest for more and more data and specific information rather than the dynamics and emotional essence.

On the other hand, the explorer can be an active part of the research team that is considering a situation from all angles. Curiousity and open-ended questions moving from the part to the whole sets a tone of valuing the supervisee's insight and reflections. The asking of the right questions can help uncover what the supervisee tacitly may know (Lidmila, 1997).

Similar to doing therapy, the supervisor needs to work at clarifying and identifying the supervisee's anxiety. Supervision is a project centered on knowing and being known. People may have anxiety about being known. This can be a benign or persecutory experience. Does the supervisor become revered, feared, envied, hated, idealized, and depended upon? In the beginning, the supervisor needs to appear safe and knowledgeable and later more questioning and not so certain. It is important that the supervisor is sensitive to the supervisee's underlying anxiety or attempts to conceal. Curiosity and desire need to be safely experienced.

Clearly understanding the parameters of supervision can contribute to building and atmosphere of safety. This is one of the first steps in supervision that should be combined with setting appropriate goals with the supervisee. The following is a list of personal and professional areas of focus for developing goals & a glossary of terms

Supervisor goals for creating a positive atmosphere

Indicators of Professionalism

Ethical Stance
- Adhering to an agreed upon moral stance of the profession (for example the Canadian Art Therapy Association Standards of Practice)

Appropriate boundaries

- Ability to separate client needs and concerns from personal ones;
- Ability to set and assert appropriate therapeutic boundaries and limits;
- Awareness of dual relationships and ethical dilemmas.

Confidentiality
- Adherence to legal standards regarding clients, and respecting confidentiality in personal responses to colleagues and co-facilitators

Excellence in work ethic
- Thorough—each part of a task is thoughtfully processed and executed
- Complete—the entire task undertaken is finished
- Accurate—the most up-to-date "best practice" principles are applied
- Timely—punctual and submission of all work by deadlines set
- Disciplined and responsible— takes responsibility to be organized and assure that all commitments are met despite circumstances, stress load, or other responsibilities
- Clear, grammatically correct writing—(according to APA format)
- Technology skills—ability to utilize current technology in research, practice and presentation as related to the counseling profession

Cultural competence
- Demonstrated skills in cultural awareness and sensitivity
- Recognition of cultural issues and concerns
- Awareness of the historical components of cultural dynamics

Communication Skills (with clients and colleagues)
- Ability to give, receive and request constructive feedback
- Ability to give oral presentations regarding issues related to the art therapy

- Clear succinct presentation of supervision issues and case studies
- Ability to give "I" messages and reflect on personal responses
- Ability to acknowledge and work with transference and counter-transference

Teamwork skills

- Ability to plan, facilitate and review groups, workshops and individual sessions
- Ability to coordinate and communicate with co-facilitators during and outside of sessions
- Ability to work together in note taking, clean up, follow through of planning and bringing issues of co-facilitation to supervision as needed

Demonstration of Therapeutic Skills

Consciously Competent

- Knowledgeable, capable of choosing strategies, techniques, for best practices;
- Theoretical learning includes awareness of culture and cultural sensitivity
- Clear understanding of the connection between the art therapist's actions and the client's response so that the art therapist can choose appropriate interventions.

Therapeutic Skills

- Effective use of active listening, mirroring, reflecting, and probing;
- Able to maintain focus on the client's emotional life;
- Demonstrates the ability to be assertive, to set limits and appropriate therapeutic boundaries;
- Demonstrates the ability to initiate therapeutic intervention in group situations;
- Able to perceive and assess the value of therapy
- Demonstrates the ability to end sessions appropriately and work on termination;

- Demonstrates the capacity for empathy (having an understanding of the circumstances and feelings of others)
- Demonstrates the capacity to develop therapeutic relationships through respect, trust building, and ethical behaviour.

Self-Awareness and Therapeutic Presence

Indicators of Self Awareness:

Persistence - sticking to a task regardless of the difficulties that may arise in doing so;

Social Deftness - the ability to assess a social situation, understand the underlying components, nuances, and respond effectively;

Growing self-concept, self-worth, self-esteem, efficacy - accurate description of self, accurate assessment of value of self, accurate assessment of ability, and accurate emotional response about self;

Growing awareness/purposeful impact on others - clear understanding of the connection between what one says, does, or does not say or do and the response to such actions from others;

Balanced (physical, emotional, social, spiritual, mental) orchestrating one's life so that one's basic needs in each area are fulfilled to assure over-all health;

Genuineness - to live with sincerity in all one's actions so that affect and behavior match values and thought;

Reflective - to intentionally review one's own actions and interactions in daily living and in counseling practice with the goal of seeking insight that leads to personal and professional growth;

Emotional maturity/intelligence – to have the energy for and capacity to cope effectively with all of life's issues as they present and to utilize that energy and capacity wisely—especially in therapeutic practice;

Particular components of emotional strengths include the following:

Zeal — an enthusiasm about life that is evident but not overwhelming;

Resilience (strength and readiness for positive change)—the capacity, willingness, and desire to make life experiences serve as foundations for growth rather than victimization;

Tolerance for Ambiguity - self-imposed patience regarding unsettling or undefined circumstances;

Emotional Regulation - an awareness of one's feeling state accompanied by conscious restraint or indulgence re: choice of action related to the feeling state—also includes the ability to assess the appropriateness of the feeling state to the present circumstances;

Discipline - self-management;

Integrity - truthfulness, honesty, congruence combined with graciousness.

Indicators of Therapeutic Presence:
- Self awareness of body language, tone of voice, quality of eye contact and non-verbal communication
- Capacity for a therapeutic level and engagement and empathetic response
- Skills in centering, grounding, mirroring, containment, boundaries and empathy

Activity: setting goals

Directions: Review the categories of professionalism, therapeutic skills, communication skills, self-awareness and therapeutic presence. Write goals to focus on. Discuss the goals with the clinical supervisor (and practicum supervisor(s) as appropriate. Periodically review the goals and set new goals. For students this should occur every semester.

Learning objectives for art therapy supervision (some suggestions for students)

Goals for 1ˢᵗ year students might include the ability:
- to build a relationship of trust with clients
- to demonstrate responsibility and respect for clients
- to develop good clinical skills (including files and record keeping)
- to show flexibility and therapeutic responsiveness
- to demonstrate awareness of non-verbal clues
- to use supervision actively and constructively
- to be willing to self-reflect
- to be willing to accept constructive feedback
- to develop and show ability to observe and assess client's use of art in therapy

2ⁿᵈ semester goals might include the ability:
- to identify core issues
- to effectively use art materials in response to client needs
- to maintain focus on emotional life of the client
- to be objective in relation to client interaction and client art
- to describe the art in detail using a phenomenological method
- to articulate theoretical issues in relation to client's issues and art
- to identify the use of metaphor and symbolic significance
- to identify and work with transference and counter transference issues

2ⁿᵈ year goals might include previous goals and:
- to enhance and demonstrate professionalism and awareness of ethics
- to address therapeutic goals with a more in depth use of supervision
- to articulate theory in relation to clinical work
- to use a variety of art therapy approaches in responding flexibly to client needs
- to take on a leadership role in facilitating groups

In the last semester, goals could include all of the above with more focus on the following skills:

- planning and facilitating groups, workshops and individual sessions
- developing and presenting case studies combining clinical work with clear articulation of theory

4 The Stages on the Journey

A developmental model of supervision considers the process of therapeutic change as it focuses on the needs and responses of supervisees. The stages of supervision and the stages of therapy overlap and intermingle. There is a beginning, middle and closing. Supervision needs to reflect the supervisee's level. The Winnicottian stages of child development fit with the developmental stages of supervising a supervisee. At first they need to be allowed absolute dependence, then relative dependence and finally the opportunity for moving towards independence. For example, one would start with the mirror stage, with empathy and creating a holding space.

It is important in the first stage of the supervision journey to be clear about basic principles that are parallel for an art therapy session. The play therapy principles outlined by Virginia Axline (1969, p. 73-4), a pioneer in play therapy, set an appropriate tone for art and play with children and can be applied to supervision.

- Build rapport with a warm and friendly relationship – hospitality for travelers.
- Accept the supervisee exactly as they are – be curious and accepting of difference.
- Establish a feeling of openness for the free expression of feelings – listen with open interest to the travelers' experiences, feelings and stories.
- Recognize the feelings and reflect them back in a manner that offers insight – respond empathetically distilling the essence and demonstrating insight and understanding.
- Maintain a deep respect for the individual's personal responsibility to solve problems, make changes and choices – remember that it is the traveler's journey and to be respectful of their choices.

- Follow the supervisee's lead – explore the countryside they take you to.
- Recognize that supervision is a gradual process and don't try to hurry it – take time on the journey – there is no end goal but the ongoing river of learning.
- Set boundaries and safe limits that are realistic to the supervision relationship and environment. Be clear about dangers on the journey and set safe parameters for both the client/supervisee relationship and the supervisee/supervisor relationship.

Starting out on the journey

A great strength that beginners bring to our profession is their refreshing vision, enthusiasm, and excitement when they first observe how the art product leads to therapeutic ends. It is that very child-like response to visual material that can be a real addition to the process of both the client's therapy and the supervisory relationship. (Riley, 1996. p. 62)

The beginning of any formal relationship like supervision or therapeutic clinical work needs clarification of the expectations of both individuals entering into the relationship. These expectations can be clarified by:

- Introductions and a direct statement regarding roles
- A contract or verbal agreement to create a working alliance. (Wilson, 1984)

An introduction to oneself as a supervisor would include a description of professional experience, training and the nature of one's orientation to art therapy and supervision. Expectations and ways of assessment should be clarified, as the supervisee will have questions like: what is expected of me? How will I be judged? How will this supervisor compare with the last one? Discussing their anxiety within the context of the parallel to their client's anxiety may enable the supervisee to not be as consumed with their own anxiety. For the supervisor - it is worthwhile remembering that intrusive or obstructive behaviour from the supervisee can stem from their feelings of inadequacy, incompetence and worthlessness.

Laurie Wilson, (1984) writes, "The supervisor serves as a model of a reflective, thoughtful art therapist, who continually examines and questions his/her work and its results." She goes on to speak about how ideally, there is a minimum of "how to" advice and how an understanding supervisor will help students learn to identify and solve their own clinical dilemmas. The self-examination of the supervisee is essential but needs to be separate from the self-examination of personal therapy. The supervisor's role includes support in identifying personal difficulties, which might be interfering with the supervisee's clinical work.

A beginning stage focuses more on the client and techniques that will bring about client change. The intention of the supervisor is to help the supervisees address the needs of their clients. It is also important during the beginning phase of supervision to lay out the kinds of topics appropriate to bring forth in supervision and to identify the importance of both positive and negative experiences to come forth. The supervisor is to become very familiar with the supervisee's work, both the successes and the mistakes.

In the beginning of the journey the supervisor tries to create an atmosphere where it is safe to expose ignorance and errors, where individual contributions will be carefully listened to and welcomed. The supervisee's role can be anxiety provoking because normally in school one is judged on one's grasp of the material and here in clinical supervision one is judged on reporting one's own work and the client's work in exquisite detail. It is important for the supervisor to appreciate the frankness, which will bring to light common difficulties. The capacity to learn and grow is what is being assessed. Supervision is about learning to think reflectively.

One of the first things for an art therapy trainee to learn is how to tactfully and productively "do nothing" and to feel comfortable about it. The focus on observation is crucial to understanding issues of timing, clinical tact, and the receptive non-judgmental stance. Focusing on developing therapeutic presence and a meditative reflective manner of engaging with clients is important. The basic expectations of this stage are: to learn the practice of art therapy; and to learn to report clinical work both orally and in writing.

A common issue is the new art therapy student's desire to know the meaning of the client's artwork - immediately. This desire will be manifested by barely letting the client finish the art before asking questions and inviting the client to "tell **me** about the picture." This emphasis on telling the therapist can undermine the reflective process as the artist/client

may not know about the picture. This may leave the client with the feeling that the meaning behind the work is more important than the work itself. The interruption of art making when the client is hesitant as to how to proceed may stop the expression unfolding. The structure of Betensky's (1995) phenomenological approach and the question of "what do YOU see?" after a period of reflective looking provides a very useful conceptual framework for the beginning art therapy student. Another facet of the urge to decipher meaning is the tendency to quick leaps to interpretation, which may provide immediate satisfaction but obscure a more accurate and profound assessment.

In the beginning there is a process of learning how to use supervision. This includes learning how to describe a client, the session, the artwork and the supervisee's experience. While the supervisor may try to draw the supervisee out with questions – they are not looking for a right or wrong answer. Rather the emphasis is on developing skills in observation, description and increasing curiousity and reflective thinking. The intention is to have the supervisee learn to observe more details of how the art is made, what is created, how the narrative connects to the art and the client's physical presence. In a phenomenological approach one is looking to get as complete a description as possible including the therapeutic environment. Learning to give a good phenomenological description is very important. Contemplate all the features: the formal and narrative quality, the size, the colours, the intensity (pressure of the drawing tool etc.), the use of space and the relationship of the parts to the whole (hermeneutic circle). To aide in getting a full or 'rich textural" description sometimes I suggest the supervisee describe the art to me as if I were blind. The description should focus on client's strengths as well as vulnerabilities – and look at the healthy functioning and protective factors for the individual and not just looking at the pathology.

Looking at the art in supervision can provide an opportunity to develop the fine art of asking open ended and reflective questions. One can explore the possibilities of concrete, metaphorical and self-reflective questions (Carpendale, 2009) and moving from the neutral "Oh" to reflective listening, to more specific questions and observations.

The supervisor should provide an opportunity for the supervisee to reflect on the effect of their interventions. Supervisees need to feel that there is a quality of graciousness about their own ignorance and that humility is valued as a therapeutic quality. They often need to hear from

the supervisor that they have the faith that they will understand and respond differently in due time.

Packing the bag and preparing for supervision

Bring questions, concerns, and successes. All clients and processes should be discussed. Choose a case, prepare to present the art, review the clinical file, and include supervisee post-session art if available. The purpose is to:

- observe what actually happens in the session;
- develop sufficient distance to analyze why it happened;
- flexible and creative in seeking alternative solutions.

A key focus in the beginning stage of supervision is to learn how to prepare for supervision, what to bring, how to pose questions, how to self reflect and respond to questions. How does one prepare for travel? What would one like to bring? Initially the supervisee has a desire to learn and to share what he or she is doing in sessions. There is a destination – a place to go – a situation to explore – a question to consider and/or be answered.

In art therapy supervision it is very important to bring the artwork from the client. This brings the client into the supervision space. The description from the supervisee is and can only be from his or her perspective – it has already been distilled and interpreted as to what is relevant or significant to bring forth. The artwork brings the actually physical mark making alive. Sometimes the artwork is brought physically present and sometimes it is brought forth digitally and projected onto a screen. The actual artwork does bring a different quality and tangibility to the artist/client. However the contemporary opportunity to bring digital images ensures the safety of delicate or breakable pieces of art – clay pieces for example – or large art works. And if a client wants to take artwork home then it can still be recorded. However, it is still a picture of the artwork and requires careful photography to show relative size and the three dimensionality of sculpture or construction. It can also be very difficult to take images of pencil drawings or very pale and faint imagery. Collage images need to be carefully photographed to not get excessive glare.

A Supervision Journal: All supervisee's should keep a supervision journal as a place of self reflection, a place to pose questions, to wonder about theoretical connections, a place for thinking about transferences

and counter transferences. In the journal the supervisee can prepare for supervision, record wonders, excitement, fears, anxiety and insights. It is a place to identify problems and successes. It is just as important to focus on the recognition of a therapeutic moment or process as it is to consider when things have been a struggle. Make notes after supervision to capture what has been learned and what is needed or desired to learn.

A small caveat - this is not a journal which would include client notes or names. This is a place where you can write about your own responses to the artist/clients and to the sessions.

Group art therapy: Planning art therapy groups is a part of the early developmental stage of supervision and the model for designing groups (Carpendale, 1991) can be a useful format. See appendix 1. A key area to focus on is the relationship between issues, needs and goals. This is of value when the supervisee is planning individual or group treatment. A supervision exercise that follows the model for designing groups can focus on section II & III:

- Brainstorm known or potential issues
- Identify the needs of the clients
- Establish goals for treatment

Settling into the journey: the middle phase of supervision

At a certain point there seems to be a shift in the client/supervisee relationship and the supervisee/supervisor relationship. How does one recognize this new phase? Are there changes in treatment and responses? During the middle or central period of therapy and supervision one can start to see an integration of theory and art expression. In treatment the basic problems, issues and dynamics will have become clearer as the more surface matters may have been cleared away. The core may be multi-faceted and the search for resolution a creative challenge to the client, the supervisee, and the supervisor.

In the middle stage there is a lessening amount of instruction and more use of questions to draw out the supervisee's knowledge. This is a time when the supervisor will introduce theoretical and interpretive frameworks to help a supervisee focus on the relationship between theory and practice. The intention of supervision is to expand the vision of the supervisee and to help the supervisee learn to ask the questions. Ultimately a good supervisor

will do less and less. A common pitfall for a supervisor is the desire to be a "good supervisor", to help, and to share one's expertise, etc.

Casework and supervision often have a parallel process in growth and change. There can be increased anxiety about interventions and the risk losing the comfortable dependent relationship. Clients may be anxious about change and if the supervisee is hesitant or unwilling to move into new areas it may affect the client and inhibit their movement towards resolution. Sometimes the client's resistance changes and more powerful defenses emerge to avoid deeper issues. This often can run parallel to the resistance in the supervisory relationship when the supervisor tries to encourage the supervisee to learn a greater sophistication, which is needed in intervention at this point in the therapy. An experienced supervisor can draw the supervisee's attention into a greater awareness of major systemic changes.

There needs to be the freedom to examine the counter transferential feelings and to be able to accept criticism and not to interpret it as blame. The supervisee may sense a shift in the therapy but be unable to identify the signs because they haven't been exposed to this level of dynamic interactions. If the supervisor shares the excitement of the positive shift in the therapeutic relationship there is an opportunity for changes in punctuation and reframing. The increased sense of trust in the therapeutic relationship and its parallel supervisory relationship allows the supervisor to encourage change in a more vigorous manner. Encouraging change does not necessarily mean interpretations but recognizing the client is in control and conscious of the process.

The art making and artwork will become more expressive and enhance the verbal process in new ways as there is more ability to self interpret. Again, it is worthwhile to reflect on the parallel process with the supervisor. The supervisee may try more risky questions, more creative interventions, and challenge the supervisor's interpretations. Indicative of their confidence and trust in the supervisee's ability the supervisor may offer more creative criticism and more challenging questions pertaining to the theoretical underpinnings of the process. (Riley, 1984) If it is viewed as a synergistic process there is the possibility of unique creative therapeutic solutions.

The process of supervision is learning to see things from the client's as well as the supervisee's point of view. A phenomenological exploration of meaning is always tentative always incomplete- never would a human lived experience be "presumed to be universal or shared by all humans irrespective of time, culture, gender, or other circumstance." (Van Manen, 2002)

During the middle phase of supervision when the groundwork has been laid out and a strong supervisory relationship has been built, there is the opportunity to explore the work in more depth and to take more risks in looking at vulnerable areas of the work.

Some of the areas and questions might be:

> What kinds of clients or client interactions do you find difficult? Do you have difficulty relating to the client's parents or teachers? What makes it difficult? What are the dynamics involved? How do these dynamics relate to you?

> Are you impacted by painful or tragic life stories that you have heard from your clients? Are there cases that you keep thinking about and feel the need to talk about afterwards? Are there images from your client's art or narratives that come back to you after work?

> Do you feel stuck with a client? Are you frustrated or feeling inadequate or not knowing what to do? Are you very tired after work? Do you find it hard to get up and go to work? Are you having physical reactions after work - like vomiting, headaches etc.? Are there cases that leave you tired, irritable or bored? Are you complaining about work, your clients or your colleagues (in your head or to others)? Have you had awkward or challenging confrontations with clients, parents, colleagues or supervisors? What happens when you get angry, irritated or upset with a client or work situation? What does it look like?

Unfortunately, not all students reach this point in supervision. There are many reasons why this challenging level is not always reached. Some of the roadblocks are:

- Time limitations on the treatment plan or supervision sessions;
- Unreasonable goals within the system;
- The working relationship has not developed due to extensive transference dynamics.

- Resistance and a lack of willingness to risk and explore both creatively and therapeutically.

As stated previously, it is also important to talk about successes and the growth of your clients. Discussing and observing therapeutic moments and movements and connecting them to theory enables a supervisee to perceive the therapeutic progress during the session and have more confidence to deepen the therapeutic relationship. This might include discussing a successful session and the pleasure of observing therapeutic change or insight; or describing a session to analyze what happened and why it happened. It also might include discussing feelings of closure and the process of terminating with a client.

An interesting question was posed when I was visiting an art therapist in Israel. She spoke of the difficulty in having her interns participate in cleaning up the studio after the session. They saw it as menial work and not part of their learning. I was surprised and spoke of how I felt it was important both physically and symbolically to clean and restore the art studio, wash brushes, wipe tables, put supplies and tools away, and that the interns/supervisees needed to see that as a metaphor for putting the feelings and issues that had emerged away so that they didn't carry them home with them. Putting the lids on the jars of paint is symbolic of putting the lid on the emotions and it prevents the paints from drying out and developing mold.

Preparing for a session – arranging the space, putting the materials out, making tea, is a time to reflect on the participants and what happened in the last session and the intentions for the coming session. It is a time to prepare one's mind – to put aside one's current concerns – and to become present in the moment. Learning to take care of the studio, to prepare for and clean up after a session are all important parts of developing a professional identity and I reflected how I thought her supervisees needed to be part of it and needed to learn to value it both metaphorically and as part of the process.

A mantra that I live by and that I teach my students and supervisees is: 'Do what you are doing while you are doing it.' This translates as work hard when you are working and play hard when you are playing – be present with what you are doing – and give your undivided attention to who you are with and what you are doing. Value it. Everything is important and when done with presence and awareness can be a deep and

meaningful symbolic experience. I believe in terms of studio care that everyone should participate – I will say "I'm good at washing dishes".

Some of the gifts of supervision are giving permission for the supervisee to hypothesize, experiment and fantasize creative moves both within the therapeutic plan and the art expression. There is protection from the supervisor to inhibit the use of inappropriate techniques. The core of the middle phase of supervision leads to the recognition of the time for termination.

The end of the journey: the desire to get home & the sadness of leaving

Separation is one of life's central experiences. Seldom is it possible to move to a plateau of greater growth without leaving a previous one. (Wadeson, 1984)

From the beginning of therapy and in a parallel manner, from the beginning of supervision, the therapist and the supervisor needs to stay aware of the relationship having a professional framework with a beginning, a middle and an end. During the closing phase supervision needs to be more about creating a space and framework to think so that the therapist/ supervisee discovers their own insights and find that they can rely more and more on their own knowledge.

The role of the supervisor is in drawing out or eliciting the tacit knowledge of the student. Tacit knowing refers to how "we know more than we can tell." (Polanyi, 1967, p. 4) It is important to draw out the knowledge of the supervisee so that they realize that they hold the seeds for the discovery and that they now have more questions to hold internally during their clinical work.

The goal of supervision is to bring the supervisee to that place in the Lao Tzu story in describing a good leader was when the people all said that they did it themselves. They need to learn how to function as a professional, consult with colleagues, speak to the client's parent, and how to report briefly and effectively to the treatment team.

Strong feelings around separation are universal and there is a parallel process and experience in supervision. Termination is felt as an ultimate separation and can be one of life's most difficult experiences, which may lead to other memories of loss and reflections on death. It is

essential that the supervisor be sensitive to the supervisee's reactions, thoughts and feelings as well as being aware of their own parallel process. Successful therapy and training can reverse itself in the struggles around termination. It is characteristic for the clients to regress and for many early issues to re-emerge. So in addition to the difficulty of separation the student/supervisee must deal with the disappointment and feelings that good work is vanishing. A resurgence of the supervisee's anger at supervisors may surface around earlier issues, which had seemed to be resolved. (Wadeson, 1984)

There are different reasons for termination and different points of focus to address:
- The completion of the client's therapy,
- The transfer to another therapist,
- Supervisee leaving a practicum or position;
- End of a therapy group.
- Ending of a group member and the group may continue and the supervisee may have to help the group adjust to the transition as well as his or her own feelings about their role in the group.
- Graduation from a training program.

Due to the various complexities and difficulties it is important to prepare in advance for termination by bringing up the issue and focusing on its importance. It is also important to interpret feelings and behaviours in light of the end. This is particularly relevant in a small art therapy school as it comes time for students to graduate. Leaving a school is leaving a structure as well as specific people, support and a way of life. Entering the world as a professional art therapist requires taking on more responsibility and maturity. Although there may have been anger at the 'infantilization' that both client and student status implies and often encourages, there may also be fear in becoming and assuming a more adult position in the world. The supervisor's understanding that termination regressions are to be expected and are not major setbacks can be supportive. Just as elderly people are encouraged to review their lives as they approach its end, so too should the therapeutic and supervisory endeavour should be viewed - including the client / supervisee / supervisor relationships. One should look at what has been accomplished, what needs to be done and what are the future directions. (Wadeson, 1984)

If the nature of the therapeutic alliance has been mainly supportive then one might focus on how much the relationship has meant, acknowledging the feelings of loss and emphasize the personal growth and professional development. The experience of a positive learning environment will have helped in developing the capacity to relate and engage and is not lost but will be carried into new relationships. Sometimes there is disappointment and frustration at what has not been accomplished and this also must be acknowledged for successful completion. If the termination is painless then it is likely that little engagement has really occurred.

The supervisee's feelings of loss may be especially strong because of the importance of working with their first clients and their zeal for practicing and the painful, meaningful and memorable experience of being in training. If the training relationship has been fruitful there may be feelings of loss on both sides. Even with adequate preparation the unknown is usually frightening and the wish is to remain in the present. The known is preferable to the future uncertainty. The life process is rarely left with a final sense of completion: usually there is a feeling of there being more to be done. Although there is always more to be done and learned in therapy or in supervision, there is a time to end and to acknowledge ending and to allow the seeds you have planted to grow and develop. This can be likened to the metaphor of harvesting the seeds at the height or end of the summer – saving them for planting in the spring.

Supervision is very important during the time of transition from school to professional work. As a student there is regular supervision and time to discussion each of the cases in depth but as a working professional carrying a heavy caseload there is not the same kind of time available. Time is a key factor. It becomes an ethical responsibility to take the time to stand outside of the work and to gain an objective viewpoint. Supervision for a working professional allows for the time to reflect on the clients and examine transference and counter transference issues. For a professional therapist it is important to focus on developing the internal supervisor and the techniques for self and peer supervision.

Supervision is a powerful antidote to burn out. Burn out, or what is now being called compassion fatigue, is the subsequent loss of empathy or sensitivity towards clients, which comes from the emotional impact of the work (psychiatric, social work etc) especially with technical and research orientations. The potential source of stress comes with the close contact of emotional pain and suffering. It is the 'chronic' or consistent

witnessing of pain and the, often, helpless feelings of witnessing that lead to compassion fatigue.

Supervision and theoretical understanding of the process of therapeutic change are crucial in the well being of the working professional. It is very important to remember that the pain and suffering as well as the responsibility for change and development are the client's. I often speak metaphorically of how we must let the pain touch our heart and then let it go through our body back to the earth. If we hold onto it and put the client's pain in our own backpack to carry we are failing to empower the client in taking personal responsibility for therapy.

Closing rituals

Pass out small pieces of coloured paper and ask each participant to write a one or two line prayer. Have the prayers placed in a basket and take the basket around to each person to take a prayer – choose a different colour of paper than you wrote on.

Judith Robertson, nature based art therapist, had a group make homemade fortune cookies (they were delicious) and write fortunes to put inside. This could also be done with bought fortune cookies. Then the group can enjoy, eat and read aloud the fortunes.

Another variation on this theme is to have all the group members put one shoe out in a circle and then all the group members write a message on a small piece of paper and place it in the shoe for the individual.

A group thank you poem to be offered in gratitude for learning and appreciations of each other. This can be done in a closing circle.

5 THE JOURNEY: MOVING ON AND STAYING STILL

To learn from experience we must allow ourselves to have an experience, to become aware of it and then to think reflectively about it. (Mollon, 1997, p. 25)

In this chapter I will discuss the actual framework and process of the supervision session. It is written with both the supervisee and the supervisor in mind. Creating the right environment and setting a good tone at the beginning is paramount. There are many different techniques, styles, models and approaches to supervision. A supervisor may have a number of different resources and an eclectic approach.

In many ways being a good supervisor is modeling good therapeutic presence and skills – while including and bringing forth the meta-language or internal thoughts of the therapist/supervisee. It is the respectful and reflective attitude that is most important for attending to the ongoing process of the developing independence of the supervisee.

Supervision is offered in both individual and group formats. There are a number of ways to start group supervision. Each supervisor will have his or her own style and process. I usually start with an opening circle, which gives an opportunity for all participants to speak to how they are feeling and indicate the concerns that they are bringing. This helps to determine priorities & set an agenda. Another way to start could be with a "check in" drawing.

An opening group exercise that I often use is to ask for "brags". Brags can be talking about seeing a good therapeutic moment occur, things worked or went well, it can be something the student did or something they observed another student or therapist do. It is important to look at successes as well as failures or problems. We can learn a great deal

by analyzing what worked. So it isn't just the brag you ask for – it is for the supervisee to describe how it was good or successful and you will try to have them articulate the underlying theory or principle at work. This is a way of keeping focused on what we are trying to achieve. Brags are important because often supervisees feel they need to only bring the problems to supervision. It is crucial to be able to recognize when something is working. Then I will ask what made it therapeutic? This is to draw out their theoretical understanding of what had occurred. It is just as important to understand the theory behind success as behind failure. Sometimes brags turn out to be a concern – but usually it is an opportunity to focus on health and strengths. This activity is an effective way to move learning into long term memory and helps to determine the students' knowledge of art therapy. It also serves to reduce anxiety and to create a learning environment for reflective thinking.

Occasionally, more often in an opening circle, I will ask for the worst things a therapist could say or do – this helps to let off steam and reduce anxiety. Encouraging students to release the fears and negativity can provide humour and the opportunity to say how they already know what not to do.

Setting the agenda will include a review of cases discussed during the last supervision. In the context of a training program there will also be time for housekeeping questions and issues: practical questions, files, signed agreements and confidentiality forms. Therapeutic boundaries and ethical dilemmas will often be discussed. For more in depth resource look for Bruce Moon's book Ethical Issues in Art Therapy.

Supervision process

Art therapy supervisors may provide supervision in a number of ways. The encouragement of free associative thought and discourse amongst participants in group supervision can function to increase a capacity for self-awareness and reflection. As stated previously, supervisor should model good therapeutic technique and be able to articulate how and why they do what they are doing. That is they should be able to both demonstrate and explain how theory and practice reflect each other and are enhanced and deepened by each other. Another technique is to think out loud and take the supervisee through the supervisor's stages in thinking. The strategy is to involve the supervisee in the learning and reflective process. Supervision can provide an opportunity to discuss how to frame

good questions and how to pursue their answers. Looking at the art provides a concrete opportunity for doing this.

In therapy one has to stay aware of oneself as the therapist – that one exists and perceives the subject – therefore in supervision the supervisor will ask for the supervisee to describe the experience of being in the session including his or her own physical sensations, emotional reactions and internal personal reflections. It is important for both the supervisee and the supervisor to remember that what the supervisee describes of the session is from his or her perspective and is not the "truth" of the session. Looking at the art brings the artist/client into the 'picture' and can provide an opportunity to see the subject from different perspectives – to figuratively walk around and get a good look and a good description.

The intention in supervision is not specifically to problem solve, although that may occur, but to gain a deeper understanding, a glimpse at truth or the essential meaning of an experience. As we become more conscious as a therapist we will perceive the essence of the therapeutic relationship and be able to respond intentionally and not unconsciously. The supervisee should be prepared to summarize the objective elements in a case history and situation. Bringing case notes into the session should be discouraged except to read a direct quote of the client regarding their art or for the supervisor to review the maintenance of the file and the quality of note taking. Learning to synthesize is important. Also it takes too much time to have a supervisee sorting through a file to pick out relevant points. This would include the personal history, significant life events: illness, social/ family changes, losses, trauma, family structure (family of origin & present family), culture, and developmental stages. As the context is presented the supervisor is attending to distilling the essence and meaning. What are all the related factors? Listen for the gaps in the narrative. The supervisor attends to the voice tone and underlying emotion in the presentation wondering about potential transference or counter transference dynamics.

In some sense the presentation of the artist/client is the naming of all the assumptions, which is very important because if one doesn't go through a process of naming one's prejudices, biases, conceits, demons, pitfalls, interpretations, beliefs, values, therapeutic goals, work pressures, they will inhabit the therapeutic space or rather they will lurk around. The next step is to bracketing out the assumptions to distill the essence. This step has a variety of forms but the idea is simple. The main thing that one wants to bracket out is that there is a problem. We want to put it aside for

a moment and look to see exactly what is happening. In order to bracket out the assumptions one has to first of all consider what they are. The assumptions are the things that have been told the supervisee about the client – likely from the referral source. This would include the diagnosis, the theory, and the client or the parents' & the professionals' interpretation of the problem and the client and the client's own assumptions about their state of being. This could also include the supervisee's perceptions: feelings, reactions & experience, transference, counter transference & projective identification. Keep hold of the concept that each pathological role has a hidden therapeutic aspect.

In phenomenology there is a focus to return to the things themselves. Here in supervision we are looking for a pure pre-reflective description, not analytical reflection and not scientific explanation, and not tracing back to inner dynamics. Focusing in the description can be of great value because sometimes the intent to explain loses the essence of the experience. If you really look and describe what you see you will already be 'bracketing out' your assumptions. The intent with this step is to look in order to see what is there. Then we can perceive the essence. What is called for here is a clear description of the client, the supervisee, and the art. This is not an explanation. Explanations and the scientific method moves past the immediate experiential data to models or laws of nature, which then control the data. While the scientific method and explanations are useful they can lose sight of the original data if one gets too involved in explaining. The personal meaning of an event may be different than the scientific meaning of an event. In the description one wants to get away from assumptions and interpretations and to get to the essence and meaning.

I have included a beginning set of potential questions intended to illustrate the different kinds of cognitive levels that could be posed in supervision. This is not intended as an exhaustive list but merely a starting point and a way to think about the different kinds of questions that can be asked. The questions could be of value in terms of self or peer supervision, or preparing for a case presentation.

The first level of questions would involve the recall of knowledge. The supervisee would start with describing a case succinctly. This could be a phenomenological description not an explanation of the client, the process and the artwork.

Questions that focus on comprehension would engage in summarizing the presenting problem, the parameters and the context. The issues would

be identified, the needs for the individual and/or the group would be discussed, and the goals would be outlined.

The supervisor might ask questions that focus on the application of theory to practice. For example: how would you create a safe therapeutic environment for the client? Or what therapeutic art activities would meet the needs of the client and work towards the treatment goals?

Supervision includes both reflecting on how the sessions and therapy is going as well as planning treatment for individual and group sessions. An underlying process would start with considering the client's issues, identifying the needs, outlining potential goals and move into planning appropriate therapeutic art activities.

With the supervisee presenting artwork and case material the supervisor might utilize analytic type questions such as: what defense mechanisms are evident? How does the style of art work change? What are indications of growth and therapeutic change? What developmental stage of art is evident?

The ability to synthesize the experience can be helped with self-reflective questions that Jacqueline Fehlner has introduced at a Canadian Art Therapy Association conference panel on supervision:

> What did I do well in the session?
>
> What did I learn from the experience?
>
> If I was to do the session again what would I do differently and why?
>
> Or - after reflecting on the art and process, what other questions or responses could you have made?

This could include asking about how the session began or ended. The final level of questions will pertain to evaluation and the consideration of evidence based progress. Identify the factors that contributed to the success of the art therapy group. Discuss the key aspects that made the difference. Develop a plan that will build on this strategy.

It is important to always encourage supervisees to ask self-reflective questions like: what makes this experience - this piece of art, this client, this situation, and this supervisee - unique and different from other lived experiences?

Example of focusing on description in group supervision

The value of focusing on the description of a therapy session in a first year supervision group was very clear when a discussion arose about an art therapy group with mentally challenged adults. The students brought up some difficult interactions and the groups participants' criticism of one member's behavior. One of the young women had been giggling constantly. Her best girlfriend told her that she didn't like all the giggling, in fact, she wanted some real contact and appreciation. The supervisor focused on the concept that this kind of feedback from her peers was not a problem but a terrific therapeutic opportunity. In the description, the overall agitation of the group emerged, then the fact that a third of the group were only minimally engaged in the art making. As a more detailed description of the environment was elicited several observations came to light: a) their regular teacher was away in hospital having surgery; b) the tables had not been cleared of school work prior to art making; c) the art therapy students had been away for 5 weeks due to holidays and course work; d) the art materials had deteriorated to a shoddy and uninviting state. Focusing on an accurate description of the environment allowed the art therapy students to see what they needed to do to create a more inviting art making environment.

Reading the map: a phenomenological framework

Clinical assessments and supervision can use the framework of seven P's, which are: the presenting problem, precipitating incident, problem parameters, personal history, protective factors, prognosis, & prescription. These key points have been integrated into the following phenomenological framework. Although in the phenomenological method one would be 'bracketing' in the reduction, even the idea that there is a 'problem'. So while much of this information needs to be brought forward - it should be named and held as 'assumptions and interpretations.' The process both of therapy and in supervision is to be focused on distilling the 'essence'.

The following information should be presented in a synthesized form – verbally not reading from the file. The supervisee should have prepared for supervision by reading the file and holding this information fresh in his or her mind. The artwork of the client should be put up on the bulletin boards so that one has the physical and emotional presence of the artist/ client in the room.

There are different sequences that can be used: the most common is to start with the introduction of the client, move to discussing the art and the process of the session and moving to exploring the supervisee's feelings and responses during and after the session. This is generally the most comfortable way to begin with supervisees but in later stages of supervision one might start with the art or with the transference. There is not a right or wrong way to proceed as one is always looking for where the juice is; where the horizon is; where the light is coming through; and it is important to help the supervisee find the essence of the process. Also not all of the following areas would be covered in the supervision session – certainly not each time – but the supervisor should keep a broad frame listening to aspects that are being covered and one's that have not been touched on.

There are many ways to look at the art and explore it in supervision. It is important to remember that not all of these ways need to be done each time. The framework presented here is intended to provide a scope of possibilities. The reality is you will explore certain aspects at different times but stay aware that the process of moving from the parts to the whole and back to the parts will provide fresh insight and perhaps widen the interpretive frame.

It is important to consider how the artwork is placed for viewing – there is the intimacy of viewing it on the floor in a circle and there is the value of hanging it vertically and stepping back to have a good look at it which has been identified by Betensky (1995). Damarell (2007) has identified the importance of valuing the art and hanging it vertically rather than placing it horizontally on the table, with the supervisor looking down. He compares it to hanging art in a gallery and the significance of the right height and view point.

The presentation of an artist/client by a supervisee

Description:

First of all the supervisee needs to introduce the client covering the following areas:

> Description of the client (physical, emotional, mental, social observations)

> Description of the environment (the clinical space, the art materials, and the set up).

Description of the session, (to look at the functioning of the individual including strengths and health rather than a specific focus on the pathology)

Reduction: Bracketing out Assumptions
- Presenting problem and precipitating incident
 - Problem parameters
 - The referral information & diagnosis
- The client/parent & professionals' interpretation of the problem.
- The therapist's perceptions: feelings, reactions & experience, transference, counter transference & projective identification.

Being-in-the-world or Context:
- The context for the individual artist/client: personal history, culture, family of origin, narrative, personal theories, developmental stages.
 - Significant life events: illness, social/ family changes, losses, and trauma,
 - Family structure/ family of origin / present family;
 - Protective Factors and Strengths of the client & family

Intentionality: Meaning and motivation
- The desire and motivation for therapy: from the client, from the family, from the referral source.
 - What is working in therapy? What stage is the therapeutic relationship? Has trust been built? Can one make a demand for work?
 - Motivation and the intention of the artist as evident in the art making process and use of materials.
- Listening to the language the client has used and listening to the language the supervisee uses. Shifts in word play can become evident. Remember that what is not said by the supervisee is sometimes as important as what is said because there is already a process of editing and interpreting.
- Transference or counter transference dynamics.

Essence: the art therapy process, the artwork and the core metaphor or insight

- Explore the essence – the meaning of the art, the work and the being of the client?
- What is the core of the problem? What is in the art? What is the essence of the individual? Art is the essence of the session and survives as a material object. Images hold the possibility of simultaneity, which is impossible in discursive or verbal communication.
- A metaphoric exploration to support the supervisee in deepening their ability to look at the art. Are metaphors expressed in the art and stated verbally in relation to the art and to the individual?
- Explore the dialectic of meaning. Dialectic of meaning means to be able to view an aspect and become aware of its dialectic opposite out of which can emerge the 'transcendent' third point. E.g.: open ---------- closed > to be able to open and close at will.

Phenomenological description of the art:
- Role of colour, line, movement and balance;
- Image, figure and ground;
- Consider function, structure and design;
- Carving or modeling: cutting away or building up;
- How are the materials used?
- Art making process
- Client's observations & narrative

- *Symbolic content:*
 - Personal associations
 - The personal dictionary of symbols and colours,
 - Social and cultural symbolism,
 - Biological or scientific references,
 - Metaphors,
 - Psychoanalytic significance.

- *Gestalt in the art: the relationship of the parts to the whole.*
 - What is in the foreground and the background?
 - What has been omitted?

- How is the space used?
- Are images moving on or off the page?

- Dialectic aspects of the art: the polarities or shadow side of what is created. (Riley, 1999)

- Defense mechanisms seen in the art or art making process. (Levick, 1983)

- Communicative function of the art - how embodied is it? (Schaverian, 1992)
 - diagrammatic, schematic, or embodied.(Schaverian, 1992)

- Developmental level or stage of the art (Lowenfeld, 1947)
 - Pre-art; chaotic discharge, stereotypic art in service of the defenses, pictographic, formed expression (Kramer, 1971)
 - Haptic or visual orientation (Lowenfeld, 1947);
 - Patterner or dramatist (Gardiner, 1972)

- Style and abstraction - when there aren't conventional referents in abstract images then our manner of speaking and style of creating becomes the referent.
 - archaic, traditional, linear, massive (Simon, 1990)

The role of the supervisor

- Throughout the presentation and discussion stay aware of the supervisee's observations:

- Where is the supervisee's focus? Warning signs or areas of concern?

- Where is the client's focus?
 - What are the needs of the client (developmental, physical, emotional, social)? The client's observations & narrative: What does the image communicate? Does it embody meaning? Is the focus expressive or communicative?

- How did the supervisee feel before, during and after the session?

- What are the co-facilitation and group dynamics occurring in the session and in the supervision group?
 - Evident and underlying defense mechanisms.

- Looking at the artwork and listening for:
 - Distinctions between subjective and objective language;
 - Metaphors
 - How does this piece of art relate to previous artwork done by the client artist or to the individual's therapeutic process or done by the therapeutic group or in the art world?
 - Strengths and health in the artwork.

Closing supervision sessions

Just as in therapy where there is a beginning, middle and end to each session, so to there is for supervision. I don't like to just reach the ending time and say 'that's it – see you next week'. I teach using the circle and open the session with an opening circle and then close the session with a closing circle. There are a number of objectives for the closing circle:

- To practice making closing remarks
- To sum up the essence of the session;
- To reflect on what was significant for them or what is still troubling them;
- To ascertain what was learned and what still needs to be addressed;
- To introduce different ways to close therapeutic circles.

In different native groups there are different protocols as to which way the talking circle should go. Ask if you have native supervisees' – otherwise I tend to alternate from the way that I went to open the circle or to give someone who has just been presenting an opportunity to reflect. Usually I will just go around the circle –often as a talking circle – without questions or responses – just the opportunity to speak and be heard. Sometimes the "popcorn" style of jumping around from one person to another is good.

But going around the circle makes sure that everyone has a voice and reduces anxiety if they are worried as to when to speak of what to say. On special occasions I will use a Quaker pattern of meetings – in that there is silence until someone is moved to speak.

I will introduce the circle sometimes giving a directive or suggestion as to what to focus on and then close the circle summing up the essence. Generally speaking I will do what I call 'stirring the pot' by which I mean giving a wide range of possible responses for closing. This is not intended to have the participants speak to all of the questions but to widen the range of places they might choose to respond to. Suggestions and directives usually emerge out of what has occurred in supervision that day - some suggestions have been (some are appropriate for openings too):

- What did you learn today – or what was the most significant thing you learned today?
- What is something that you are doing well and what is something that you would like to learn more about?
- What would you like to leave in the circle and what would you like to take with you?
- Speak to how you are feeling right now and turn to the person next to you that will speak next and tell them something that you appreciate about them.
- What are you going to do for self care – tonight or this week?
- Give a sound or gesture to express how you are feeling.
- Give a metaphor of water to express how you are feeling (or fire, or air, or earth).

In my final closing remarks I want to value what has happened in supervision, emphasizing my respect for the courage of the supervisees and recognizing the internal and external therapeutic work being done. It is important to honour deep reflective exploration when supervisees are sharing vulnerabilities as well as strengths.

6 TRUE NORTH & THE INTERNAL COMPASS

Eleven
Thirty spokes share the wheel's hub;
It is the center hole that makes it useful.
Shape clay into a vessel;
It is the space within that makes it useful.
Cut doors and windows for a room;
It is the holes which make it useful.
Therefore profit comes from what is there;
Usefulness from what is not there.
(Tao Te Ching, Feng & English, 1972)

The internal compass in the internal supervisor and the 'usefulness from what is not there' in this poem speaks to how the space functions to enhance 'tacit knowing' and will leave the supervisee with not only the feeling but the reality of having insight and a sense of direction. This will come from reading a map of where they have been with the artist/client and becoming aware of the terrain they are entering into. True north refers to intuiting the essence and learning to find truth and being from the inside. This aspect of learning to do it oneself and not just having it given to will over time lead to the supervisee seeing, knowing and responding differently in the session. This will be because they have become able to understand the needs encountered traversing different terrain and they have become more able to read the legend of the map and relate it to True North and the internal compass.

The intention of the supervisor should be to create a space for reflective thinking in terms of both an internal and external framework. The supervisor's intrinsic way of being will contribute to the internal construction of a grounded atmosphere and the creation of space for

thinking together. Acknowledgement of the supervisee's work and its intrinsic value is important. Keep an eye on the strengths and enhance and encourage the positive directions of their thinking.

The supervisor's fundamental attitude and beliefs regarding the supervisee are important.

Some basics are: a) acceptance of the supervisee - don't expect them to be more advanced than they are: b) respect -acknowledge their strengths and intentions; c) belief in their ability to understand and solve their problems.

The supervisor needs a good internal compass to be: trustworthy, tactful, honest, not humiliate the supervisee. He or she needs to refrain from discouraging the premature closure of ideas and to keep a curious stance of open-ended research and inquiry. A supervisor who provides too an easy solution or understanding can be anxiety provoking and stimulate a desire to avoid the unknown. Although sometimes it seems that the pressure of time precludes this, in the long run it will undermine the supervisee's ability for independent thought. A supervisor should never appear too certain – they should stay open to explore more tentative hypothesis and speculations. It is of value for the supervisor is to think aloud to share their thought processes. It is not so helpful to be sure and always is right.

Creating a good framework takes time. The place of perception and the listening in supervision is very like the listening in therapy. Although it is not therapy, it is safe to assume that the student/supervisee will be feeling vulnerable. Therefore, it is important initially to build a relationship of trust and develop an approach that looks at strengths as well as at areas, which need to grow and develop. Too often most of the time is taken focusing on the supervisee's inadequacies, the client's problems, the issues, and the trauma. It is always important to look for strengths and the health in an individual and in the therapeutic relationship. Parallel to how I often think that my role as a therapist is to keep sight of the health in a client until they start to experience their health and give it a chance to grow and expand, the supervisor needs to keep sight of the strengths and value in the supervisee while they are free to explore their anxieties and difficulties.

A decrease in the supervisee's associative thinking is likely reflective of an increase in the supervisee's anxiety as it might lead to being more exposed or making mistakes. The intent is to encourage free associative thought, discourse amongst participants and a capacity for self-awareness and reflection. It is important to give permission for the student to hypothesize, experiment and fantasize creative moves within the treatment

plan through art expression. Supervision hopes to develop skills of flexible thinking and the ability to think on your feet and be responsive to a therapeutic situation. The intention is to enhance the supervisee's skills in devising successful therapeutic strategies, to create a space for problem solving, to learn therapeutic strategies and techniques, to develop creative approaches to clinical problems and to suggest intervention strategies for treatment. In the beginning the supervisor needs to appear safe and knowledgeable and later more questioning.

Feedback and reflection will not be experienced as a threatening event if problems and transferences are viewed as an opportunity to learn and grow, if they are seen as underdeveloped aspects, which if given light and attention will develop into strengths. My memory of training with Dr. Martin Fischer, psychiatrist and art therapy pioneer in Canada, was that we were treated as if we'd laid a golden egg anytime we'd brought forth a difficulty or a transference issue. It was viewed with interest and excitement as if now we have an opportunity to learn something new. This encouraged the constant examination of issues, transferences, and counter transferences.

A good internal state of mind for an art therapy supervisor is kindred to the attitude of a phenomenologist. The focus on discovering truth and essence via intuition is central. As stated previously, in the phenomenological method the focus of the reduction is to bracket assumptions and thus to provide an attentive curious and reflective focus – with a diffuse gaze and an open attitude of listening not just to respond but to attend intuitively to where the intensity, essence and meaning might emerge. Bion quoted Keats saying the goal is: "to listen without memory or desire, to observe 'without irritable reaching after fact and reason'" (Mollon, 1997, p.28).

The supervisor has to imagine the client and the therapeutic work with the imaginal client. Understanding the client will come from listening to the supervisee and looking at the art. It is important that the supervisor can identify with the client; that they feel in contact with the client through supervisee reports. Supervision provides the opportunity to focus on the essentials of the contact because one is not distracted by the narrative and personal dynamics. (Bradley, 1997, p. 55) One is aware of positive and negative flow of communications. It is important to not feel obliged to provide insights.

A supervisor needs to develop the same kind of state of mind that a therapist needs to be in – a state of "active dreaming", or "responsive reverie" – where one allows time to reflect and unravel the meaning of a session. The supervisor needs be able to listen without seeking immediate understanding

and to take the time to allow meaning to be distilled over time. A supervisor needs to have a capacity to free associate and to hold an "attitude of evenly suspended attention" (Crawford in Driver, 2005, p. 57). Mollon explores the importance of creating an open and reflective space in supervision where reflective thinking can occur. He speaks of this as involving "mulling over, sifting through impressions without hurriedly coming to conclusions; it is free associative rather than directed, allowing thought to germinate and develop in the mind and in the discourse between participants." (1997, p. 24) To hear what hasn't been said or to see what hasn't been seen. It is important to keep the diffuse gaze and to listen to what one doesn't expect because otherwise one can be in danger of never finding anything except what one already knows. This manner of being in supervision is somewhat like dream interpretation where when one associates to the manifest content the latent meaning can become clear.

The essence of a hermeneutic phenomenological approach to supervision is to have an open and reflective state of mind that can move from listening and looking at the parts to the whole and back again. Similar to a process of meditation, the supervisor needs to be able to tolerate "not knowing" and to allow conscious and unconscious feelings and associations to emerge and reverberate in his or her mind. Conscious awareness of working with the hermeneutic circle can provide a framework of exploring layers of meaning and the knowledge that the possibilities of symbolic interpretation are inexhaustible. It is this awareness of the process of making meaning that is significant – in essence meaning is not a given but a construct.

"Presenting work in supervision will always involve exposure and anxiety, and the risk of feeling shame, or even humiliation, as a consequence of that exposure. " (Crawford, in Driver, 2005, p. 57) One of the initial challenges for a supervisee is to tolerate letting the supervisor know all the aspects of what goes on in the art therapy studio.

It is important to have a clear intention regarding supervision: "Task is to think and talk freely, reflectively, without censorship, about an experience." (Mollon, 1997, p. 31) Sometimes supervision is used as a space for unburdening or unloading, sharing pain etc. One should feel the emotion but not be shaken and to still be able to stay thinking clearly. It is important to stay with the process – and to not get scared and run away – to allow the meaning to become clear. Patterns will emerge. The skill is to contain the affect and try to understand what is being communicated, and to go on observing. The supervisee needs to express their impressions, fantasies, and feelings.

Art therapy supervision skills include reflecting back; providing empathy and back up support which allows for the supervisees well being and coherence of self. The supervisor needs to provide a background consistency and a focus for the therapist/ supervisee to integrate and internalize a reflective mode. The intention of supervision is to enlarge the therapist/supervisee's cognitive and emotional work space.

With a focus on wanting the supervisee to develop critical objective thought it is important not to give more answers than are absolutely necessary. However, that being said in the early stages of supervision there would likely be a need for more specific instruction.

In supervision groups, it is important to counteract competitiveness by valuing and considering each supervisee's contribution not just by being tactful but also to reflect on the uniqueness of each response. Try to follow their line of thinking. Encourage an open report of the flow of a session – the more detailed the process and the dialogue the better – value honesty; value mistakes and self reflection.

For the supervisor it is important to reflect on the kinds of issues and concerns brought forth. What does the supervisee chose to relate or not to relate? This implies an interpretive framework. There are certain things, which are included, and certain things, which are excluded. Certain aspects have been brought to the foreground and certain aspects are left in the background. It is important to look at what is valued and considered relevant or irrelevant. What are the distractions, the disguises, and the defenses of both the client and the supervisee?

Following the theme of metaphor one can focus on the landscape or the narrative of client or the subjective inner space– being a voyage of discovery. Try to find a place where innocence and ignorance can become revealed. A systems approach can be used and one can apply the psycho cybernetic model of encouraging healthy loops and discouraging unhealthy loops. Positive self-reflection – "attention seeking" behaviour can be directed towards self-exploration and insight. It is important for the trainee to speak of their experience because in this way they can become aware of what hadn't been articulated before.

The supervisor hears about both the client and the therapist – the therapist speaks of his/her experience. The supervision session is to create a place of more objectivity. Supervision is an opportunity for teaching critical thinking. In critical thinking one must always keep track of the figure ground relationship and keep track of the relationship of the narrative to the context. This is particularly important regarding cross-

cultural issues or different social classes. The client's context may be quite different to your own. It is important to not become lost in the narrative. The role of the supervisor is to stay aware of the possibility of projective processes that the client unconsciously but actively may try to create in the therapist/supervisee.

In many ways supervision is a project centered on knowing and being known. This can be a benign or persecutory experience. People may have anxiety about being known. What does it mean to know and how do we know? Does the supervisor become revered, feared, envied, hated, idealized, and depended upon? Thus supervision includes the personal and emotional aspects of the supervisee's clinical experience and it is also an opportunity for teaching critical thinking. The curiosity and desire of the supervisee will need a contained space to be expressed and reflected upon.

Exercise: Let your Image find its Voice
(Carpendale, 2009)

This exercise is designed to encourage the development of self-awareness and self-expression. It integrates the phenomenological method with gestalt art therapy and poetry. Its focus is to bring the creative act into language with a movement from creating an image to writing poetry. The intent is to uncover hidden essences, to release the poetic voice and to make a translation from the visual image to the written word and then to give voice and be witnessed.

Directive: Create art to express an image of healing or a metaphor for therapy, or spontaneous art. Look at the art and write a description. Not an explanation or interpretation, but a description of what you actually see. From the description take each aspect of the art and write a statement in an "I" voice. This part of the process serves to enhance the meaning and intentionality of the artwork. Write a poem in response to the writing and to the art. This process can function to distil the essence.

Provide an opportunity for supervisees to read their poetry and show their art. This will bring the individual and their creative process into being-in-the-world. Accept and honour each individual's art and poetry giving permission for them to share what they choose. The significant aspect here is to be heard and witnessed. Silence can be an expression of respect.

7 THE LEGEND ON THE MAP

Interpret:
1) *To explain the meaning of; to make understandable, as by translating; to elucidate.*
2) *To have or show one's own understanding of the meaning of; to construe; as he interpreted the silence as contempt.*
3) *To bring out the meaning of, especially to give one's own conception of, in performing, criticizing or producing a work of art.*
4) *Syn. Expound, explain, translate, decipher, construe, unravel, unfold, solve, elucidate*
 Definitions from Webster's 2nd edition

This chapter was originally called 'Interpretation is not a dirty word' and will explore the place of interpretation within the context of art therapy supervision. Consideration will be given to the function of words and language and a variety of ways to extend the supervisee's thinking when looking at art in supervision.

The focus in art therapy training is to become cognizant of our interpretive assumptions. Because it is only if we are aware of them that we can bracket them out and look to see from a fresh perspective. Any discussion regarding interpretation runs the risk of sounding dogmatic and formulaic. In supervision it is important not to forget or under estimate the value of uncertainty and ambiguity in creating knowledge (Driver, 2005).

The interpretation of an experience functions to define it and although this shift in awareness may lead to insight it may also cloud or exclude more elusive aspects. Therefore it is important to attend to the more relational aspects that will increase reverie and to beware of the desire for

certainty and the urge 'to know'. The goal in supervision is not to satisfy the supervisee's anxiety about 'knowing' but to enhance their ability to access an internal reflective dialogue (Driver, 2005, p. 31). "The aim of interpretation within supervision is to engage the supervisee's internal world and stimulate dialogue between the conscious and unconscious in an internal dialectic that generates insight." (Driver, 2005. p. 17)

In therapy, often considered the 'talking cure,' the therapist will be attending to both conscious and unconscious processes, and will be listening not only to the words the client uses but how the words are said and how they impact and affect the dynamic. In supervision the supervisor is attending to the words and language used by not only the client, as reported, but also the supervisee. In supervision as in therapy it is important to attend to visual and visceral perceptions, and to what is thought and spoken of both in the session and in supervision. The words, the language, and how it is expressed is part of the core material to be reflected on and explored giving consideration to both the therapeutic session and the supervision experience.

A positive supervision process will stimulate the internal dialectic. Both the supervisor and the supervisee are trying to make sense of the 'lived experience' of the art therapy session – the forms or processes used may include writing, art making, reflecting on the artwork, or reviewing a video tape of the session. Bringing insight to consciousness requires language, a translation, an interpretation, a witnessing that includes the felt body sense and language that connects the experience to a theoretical understanding.

Piaget distinguished between two different modes of learning: assimilative learning – where the gathering of new information is brought into existing systems of thought; and accommodative learning – where new information requires a shift in our cognitive schema. Both kinds of learning styles will be important in supervision – however, there may be more emphasis on one style or another during different stages. For example: in the early stages of supervision for the developing art therapist there may be more assimilation – but during the middle stage accommodation is often required to reframe previously held beliefs and knowledge.

Let us consider the impact of interpretation: what does an interpretation do? What impact do the words have? How are they spoken? How are they received? What filters are present?

There is an ongoing discussion in the art therapy world regarding the process and method of symbolic interpretation with the art. It is

my hope that all art therapists are taught to be extremely careful not to impose interpretation on their clients. In most approaches to art therapy there is an underlying premise that it is most important for the artist/client to interpret his or her own art. There is no doubt as to the value of the client's own insight and discovery of the significance of their artwork. But the question is - how does this come to light? Insight occurs as the client is involved in creating the art; when they look reflectively at the art; and when they speak about their art. Talking about the art happens in dialogue with the art therapist. The art therapist holds an underlying interpretive framework, which gives direction to responses and questions, frames their responses and sets a tone for the reflections regarding the artwork. Specifically, in training to become an art therapist there is an emphasis on becoming aware of one's own interpretative assumptions and learning to edit out interpretive remarks and prescriptive comments or questions.

In psychoanalysis the key value attributed to an interpretation is the question of whether or not it leads to the production of more 'material'. 'Material' here refers to the unconscious associations – thus from a psychoanalytic perspective the correctness or value of an interpretation is determined by whether it produces more material. It is not about whether the client accepts it or discards it, nor whether it has a particular impact on the client, but whether through the dialectic exchange more associations and feelings emerge. The supervisor should give consideration and value to the discarded comment or artwork and not accept carte blanche the supervisee's preconceived notion of the 'real' material – the 'real goods'.

Winnicott (1980) articulates how interpretation can function to allow the client to see the limits of the therapist's understanding – to thereby facilitate the client working towards his or her own understanding. In terms of supervision – interpretation by the supervisor should function to increase the supervisee's ability to develop his or her own understanding. Bollas refers to the function of interpretation to structure the experience (in Driver, 2005). Vygotsky identifies the primary function of speech to be the development of dialogue in communication and that egocentric speech is the precursor for the development of inner speech (2002, cited in Driver 2005, p. 23). These concepts relate to Casement's idea that the external supervisor becomes over time to be the internal supervisor and that the method of supervision with questions and reflective processes becomes internalized and then accessible to the supervisee at all times. It has been my experience that when I have a question and I ask myself what would

one of my mentors' say or do that I then can access that knowledge and I am able to move forward. My own graduates tell me that they hear my voice in their head when they need it. I am speaking here metaphorically of the process whereby knowledge gets integrated into the self and it is, of course, one's own knowledge and voice speaking to oneself.

In supervision it is important to take the time to look at the art – to see more of what is there and to tease out potential meanings and significance. Writing about the art in the clinical files also facilitates a process of looking and reflecting on the artwork. Barnet writes "We write about art in order to clarify and to account for our responses to works that interest or excite or frustrate us. In putting works on paper we have to take a second and a third look at what is in front of us and at what is within us. And so writing is a way of learning." (1993, p. 1) Looking at the art is definitely a way of learning.

The beauty of looking at the artist/client's artwork in supervision is that we can explore a variety of possible interpretations. Without insight into the process of symbolic interpretation there would be no direction to the questions asked. So looking at the art in supervision is a safe way to develop skills in exploring metaphors, elucidating symbols and practicing a phenomenological unfolding of the images in the artwork.

What we hear about in supervision is what is presented to us by the supervisee – the art is the only actual relic of the therapeutic exchange. The artwork represents the client – it is both symbolic and real – the gesture, marking and choices of the artist are evident in a tangible and concrete form. It forms a third point in a triangle, which includes the supervisor and the supervisee. For the supervisee the process of looking at the art avoids some of the problems of remembering the session or distorting by selective memory. To view the image or sculpture in supervision brings a tangible part of the session into supervision, which can then be re-experienced. With the new digital age with cameras, laptop computers and projectors, supervisees may be bringing in photographs rather than the real artwork. While this may protect the artwork from transport and may be logistically simpler for the supervisee, it is important to remember that it is not the actual artwork – it is a representation of it.

Looking at the artwork in supervision can bring in more information and the potential of more questions and insight into the situation. Otherwise all we have is the student/supervisee's version of what happened. This is similar to trying to discover something new from what is already known. The art brings a new dimension. In fact, if the student/supervisee

is not bringing in the artwork regularly – this may pertain be indicative of a problem perhaps of not valuing the artwork and creative process in the session.

Art work can function in supervision to bring the real situation into a tangible, visible concrete reality. It enables the creative activity to mediate the supervision. It brings the presence of the artist/client in to the supervision session. It brings in the unknown and unconscious aspects of the artist/client and the supervisee/therapist relationship from the therapeutic session into the supervisory session. The artwork is fully encoded with information. Supervision without the art present is kind of like having an art show where there is no pictures hanging and the artist walks to each numbered spot and tells the viewers what each piece of art is about without the audience being able to see the art work for themselves. In this situation we could hear the narrative, the metaphors and the associations but we don't see the actual artwork and have our own perceptions and response to it.

It gives an opportunity to ask about what you see rather than what the supervisee has seen and has decided to tell you about. The supervisee may not be aware of all the relevant aspects of the session to bring to the discussion and he or she may be anxious about being revealed or found inadequate and therefore be editing internally the narrative of the session. There is both a desire to be known and seen and a fear of being known and seen. The supervisor can work to create a climate of exploration and honesty and can speak to the importance of the self reflective process in supervision. The concept that a problem is an opportunity to learn is often very new to beginning supervisees and it may take a while for them to feel accepted and to build trust in the supervision process.

The Process of Communication

Fiske (1982) outlines two main schools in the study of communication. The first is the process school, which focuses on the transmission of messages: the encoding and decoding of messages and an examination of the senders and receivers. The process considers how one person affects the behaviour and state of mind of another. If the result is different than intended it is thought of as failed communication. The process school draws on the social sciences and psychology and looks at the acts of communication. The second school in the study of communication theory is semiotics, which focuses on the production and exchange of meanings; looking at how the

messages and texts interact with people to produce meaning and culture. Semiotics is the science of signs and meanings. This school of thought draws on linguistics and art and addresses the works of communication. Art therapy includes both schools of communication as it looks at both the artwork and the dialogue. In the dialogue attention is paid to the language and metaphors used, to the manner of communication, to body language, tone of voice and gesture. In the artwork the signification or "meaning is the result of the dynamic interaction between sign, interpretant and object" (Fiske, 1982. p. 49)

The art therapy supervisor will pay attention to both the visual and the verbal language. They will look at the art and listen to the language the client has used and listen to the language the supervisee uses. Shifts in word play can become evident. It is important to remember that what is not said by the supervisee is sometimes as important as what is said because there is already a process of editing and interpreting.

Looking at the art in supervision gives an opportunity to practice exploring it in-depth. Looking at the art in supervision is similar to when working with a client. With a client one moves and flows with their focus and tries to expand the view but one never has time to exhaust the possibilities of symbolic significance. So looking at art in supervision gives the time for another look at the art and to pose, muse about other possible questions, directions.

Looking at the art in supervision provides both freedom and constraint. There is the freedom in that the client artist isn't present so that more questions and wonders can be raised without the fear of the client artist being disturbed by the exploration of suggested interpretive frameworks. It is constrained by the need to not overwhelm the supervisee and the need to elicit the insights and explorations from the supervisee. It is also constrained by the need to not have the supervisee think that they should now go and ask all the questions raised or tell about all the insights and symbolic explorations. Or that next time in session they should ask a million and one questions? This is a very important point for the supervisee to realize that the exploration of the art in supervision is different than in session.

When looking at the art in supervision it is important to make sure that the supervisee doesn't think that everything they did was wrong; that they should explore all those new aspects of the art; and that you are giving them permission to ask or make interpretations to the client. A hermeneutic phenomenological approach to looking at the art can help the supervisee develop skills in the phenomenological method.

Supervision is a project centered on knowing and also being known which can be a benign or persecutory experience. Edwards writes: "Powerful transferential feelings may be mobilized with respect to the hope or fear that the supervisor will be the fountain of knowledge and wisdom, a provider and comforter, an object of admiration or envy, a judge or some other figure of authority." (Edwards, 1997. p. 15)

The supervisor has to imagine the client and the work with the 'imaginal' client. They try to understand the client from listening to the supervisee. There needs to be a balance of support and challenge to explore the anxieties and defenses and to recognize and develop strengths.

It is important as a supervisor to understanding our own hermeneutic frame - to elucidate and learn to draw out the supervisee's insights. The supervisor's process needs to parallel the supervisee's relationship to the client - in that if they discover how to look and see they will start to see more in the session itself. If they rely on the 'great insightful" supervisor, they will not build the skills they need to develop as a therapist. In fact, often the supervisor needs to withhold and not offer or give the insight, they need to draw out the questions and insight from the supervisee themselves.

The supervisor keeps in mind the following: What are the distractions, the disguises, and the defenses of both the client and the supervisee? What does the supervisee chose to relate or not to relate? This implies an interpretive framework. There are certain things, which are included, and certain things, which are excluded. Certain aspects have been brought to the foreground and certain aspects are left in the background. It is important to look at what is valued and considered relevant or irrelevant.

An example of this is what I call "being lost in the narrative or details of the artwork" this is when a trainee focuses so intently on the words, the content or the symbols that they lose the overall meaning or essence. Just as a pianist who focuses mainly on his fingers can paralyze his movements, and that affects his interpretation of the music. One can be reconnected by looking at the art, at the sentence or at the music. The recovery may deepen the meaning rather than just bring back the original meaning. "It is not by looking at things, but by dwelling in them, that we understand their joint meaning" (Polyani, 1967. p. 18).

Supervision is an opportunity for teaching critical thinking. In critical thinking one must always keep track of the figure ground relationship and the relationship of the narrative to the context. This is particularly important regarding cross-cultural issues or different social classes. The client's context may be quite different to your own. The phenomenological

method helps to discover the essence and to not become lost in the narrative.

In supervision a metaphor model can be utilized by exploring the metaphors that the supervisee uses in relation to the therapeutic process, to the client and to the client's artwork and narrative. The following ideas emerged through encouraging a supervisee to expand their symbolic understanding of the metaphors presented through a client's artwork. A pencil drawing done by a teen girl showed a studded dog collar around the girl's throat. While these dog collars have become fashionable for some groups of teenagers there are symbolic meanings that could be considered. Through discussion the following concepts emerged. A studded dog collar on a dog could be there because:

> It serves as a warning regarding being a dangerous dog that could be aggressive.

> It functions to protect the neck, a vulnerable part of a fighting dog.

> A dog collar indicates that it has a master.

> It allows a master to control it through a leash.

As these ideas emerged that perhaps the client was both warning about her aggressiveness and her vulnerability, while also indicating her desire for attachment and connection, the supervisee felt that this accurately expressed the underlying issues for the client. The supervisee's empathy and sensitivity was enhanced by the insight into the relationship of vulnerability to aggressiveness.

Exercises

The following art therapy directives can be used for practicing therapeutic skills in debriefing using dyads or triads.

Directive: Create 2 abstract images perhaps using paint: make one that you like that pleases you and one that you don't like - that displeases or disgusts you. Look at them together and look at the metaphors and ways that they relate to each other with similarities and differences.

Directive: Make an image for the resources that helped you to survive a trauma. Then make art about the trauma. Look at the images together and let your eye and heart be grounded with your visual depiction of your internal resources while processing the trauma. Judith Siano has developed this concept in depth using EMDR and art therapy for emergency response work.

Directive: Create inside outside boxes (Carpendale, 2009) and after debriefing in dyads write the description & notes for the "artist client" and share notes – to learn if you captured the essence. This is helpful in learning to write notes that a "client" can read. There are many variations on creating inside outside boxes but the basic directive is to create art on a box or three dimensional form usually using collage and on the inside express how you feel on the inside and on the outside how you present to the world and/or how the world sees you.

Directive: Create art on a supervision concern and then exchange with a colleague and write a phenomenological description, underline what you feel is the essence and create art in response. Return the writing, artwork and response. Take time to look and then discuss. (AATA conference, 1996) **Therapeutic caution: This is not an exercise for clients or beginning supervisees.**

Directive: Supervision training exercises (Judith Siano, 2004)
- Show images from a case study -then have students write a phenomenological description of the art.
- Then show the images again and talk about them with the client's comments.
- Then do a feeling response in the art.

8 CHALLENGES ON THE JOURNEY: DELAYS & OBSTACLES

Some journeys go more smoothly than others, however, some of the most memorable ones have unforeseen delays or difficulties, that require a change in plan. This may include staying longer in one place, meeting local people, needing to ask for help or to stay and help others. In any case it is unexpected and one is operating outside of one's comfort zone. All of this is not problematic if you relax and learn to be in the moment with what is actually occurring. However, just as on a journey if you are traveling with someone who persists in complaining about every variation on the trip and consistently projects negative attributes to the situation it can become very challenging.

Using the metaphor of creating a garden, there are rarely parts of the garden that are immediately successful, unless you are transplanting fully grown plants, which could be a metaphor for supervision or consultation with professional art therapists. However, with all art therapy interns/supervisees, using the metaphor of making a garden, there is going to be a process of creating the right environment, planting seeds, watering them, weeding out extra 'volunteers', pruning when needed, and so on. If there are difficulties in the garden, the gardener goes through a process of determining what is not working or is needed for a specific plant. Does it have enough light or too much light? Does it have enough water or too much water? Does the soil have the right nutrients and does it have enough humus? Are there the valuable insects and animals that help in the garden, like bees for pollination and worms to bring air down to the roots? Are there animals, birds, or insects intruding, destroying or eating seeds and plants? Has a bush or fruit tree been shocked by being too harshly pruned? I could go on, but I hope you can see that extending

the metaphors, in this case metaphors for working in the garden - can be applied to supervision.

If as a supervisor/gardener one has taken the time to create an environment conducive to learning and reflection, then difficulties in supervision can be looked at with curiousity as opportunities to learn and grow. This ongoing attitude of a problem not being a problem is fundamental to deep transformation. It can be viewed as a parallel process to the therapeutic process. In following the garden metaphor the weeds and parts of the garden that are not growing where you want or overflowing can be pulled out and piled into the compost pile. The compost is a very important part of an organic garden it is where you put all the organic refuse (garbage) from the kitchen and the garden and combine with earth – let rest, heat up, gestate and turn periodically – and lo and behold it becomes the black soil of fertility. Similarly in supervision the supervisee's struggles in practicum placements, personal neurosis and life experiences can be composted.

That being said, there are definitely times when there are difficulties in supervision and times when it does break down. It is important for the supervisor to consider how did the processes of learning change from a good to a negative experience? Sometimes a supervisee has anxiety and an internal conflict between the 'desire' to be known and fears that if they are really known then all of their problems and shortcomings will become evident. Supervision may contain the "forbidden' shameful seeking of knowledge – or risking humiliating exposure, defensive concealment (Lidmila, 1997). Sometimes desire and fantasy can create the potential for a disruptive relationship.

It is important to pay attention to the dynamics of shame. You don't want to have your supervisees feel like they are ignorant. They may disregard the value of their own human experience. Perhaps the supervisee has a loss of faith in the therapeutic process and / or a lack of faith in the supervisor's ability to see his or her health, growth and therapeutic ability to understand and resolve their own personal issues. Perhaps the supervisee has a lack of respect for the supervisor due to negative transference issues or there is some other failure of the holding environment.

Some of the more common difficulties in the beginning stages of supervision are on the spectrum between anxiety and defensiveness in the supervisee to the risks of over confidence and lack of awareness. Another dialectic which can occur is with one supervisee being too quiet and another being too talkative. A supervisee may hardly give any information

because they feel that they basically don't have any problems and don't need "help" and don't want to be seen as inadequate. He or she may say that everything is "fine" and "going well" and will only chose a small question to bring forth. Supervisees that never bring forth serious concerns may be wishing to appear competent and knowledgeable. Another may want to talk a lot to impress the supervisor with what they know and did. A hatred of feeling ignorant can make it hard to learn from experience – the supervisor may want to have the supervisee discover the insight in the process. Establishing an atmosphere of respect is important.

In the middle and later stages of supervision a supervisee will still be interested in discussing a case in depth even though everything is basically "fine". A positive focus on vulnerability and self-exploration can create a feedback loop in the group that communicates the value of deep reflective exploration. The supervisor tries not to feed the supervisee's desire to stay on the surface with their position of everything being fine.

There may be difficulties in the beginning stage of supervision with the supervisee not having prepared for supervision – not having packed what would be needed for the weather or location. They may not understand the purpose of the journey and may not appropriately prepare for supervision. Issues like consistently not bringing the client's art, perhaps may indicate anxiety regarding allowing the unconscious in. Or the supervisee's focus may be entirely on diagnosis or psychodynamic analysis and formulations or the client's narrative history.

It is important for the supervisee and supervisor to be able to cope with a period of uncertainty and a breakdown of understanding (Bradley, 1997). The difficulties of a supervisor can depend to a certain extent on the criticalness of his superego. How does the supervisor handle his own guilt at the breakdown of communication? Does the supervisor blame him or herself or blame the supervisee? Can we tolerate our own personal shortcomings?

Some of the questions might be: what is present and what is absent? What is the opposite of what is being presented? For example if a supervisee is always talking about successes in therapy or says everything is going fine and that they don't need to take time in group supervision. Is it because they don't want to bring problems to light or that they don't realize that they have difficulties? Or do they feel that they know all there is to know about therapy or about these particular clients? Are they taking things "for granted"? Perhaps the supervisee has been seduced by the positive aspects of the therapeutic relationship.

Do they wonder where the negative transference might be emerging? Are they intent on the narrative of the client? Are they intent on the narrative of the session? Are they curious about what is not being said? Are they wondering about what happened before? Or do they have different perspectives or view points on the individual? Are they attentive to the relationship between the internal life and the external life? Are they listening to the metaphors being used in language? Being expressed in the art? Are they attentive to the physical presentation of the client in movement, gesture, voice tone and process of creating art?

Are they aware of their own responses to the client: physically, emotionally and mentally? How do they feel after a session? What is it like to write notes? Can they remember what occurred? Do they remember significant pieces later? What is the difference between what is written and what is spoken about in relation to the art and describing the session? Are they able to give a description of the session rather than an explanation? Are they aware of their own intentions? What is the essence of the artwork? Of the session? For the client? For the supervisee?

In both art therapy and in supervision it is important to attend to the relationship between listening and responding. Sometimes there can appear to be a basic intolerance of silence that may come from the artist/client, supervisee, or supervisor. In group supervision it is important to stay aware of the balance of verbal participation. The use of the talking circle can encourage quieter members to participate. Sometimes the quiet is a cultural quality of showing respect. Aboriginal supervisees may wait until there is silence before they will contribute.

While it is quite normal for supervisees' to be concerned to appear competent and knowledgeable, the possibility of intense anxiety and hatred of feeling ignorant can make it hard to learn from experience. Supervisees may anticipate criticism and judgment. Treating the supervisee with respect can lead to his or her desire to discover the insight in the process. Sometimes this anxiety can manifest through the supervisee's focus on diagnosis or psychodynamic analysis and formulations, or an intense focus on the narrative history, or by not bringing in the art, thus not allowing the unconscious in. If the supervisee doesn't bring in the art – the supervisor is being presented only with the supervisee's perception of the session. The artwork functions to bring the artist/client's presence alive in the supervision.

Competitiveness may be evident in group supervision – this maybe with other supervisees or with the supervisor. This is where the positive

focus on vulnerability and self-exploration can create a feedback loop in the group that communicates –the value of deep reflective exploration –the supervisor tries not to feed the supervisees desire – to stay on the surface and with everything being fine. It is important to attend to interferences with freedom of thought, put-downs or dismissive comments.

There are dangers inherent in being a very experienced and respected supervisor – as supervisee's may be looking for any and all cracks in the vessel. I am reminded of a line in a Leonard Cohen song "there's a crack in everything, that's where the light gets in."

Searles (1965) writes:

> One of my most oft-repeated experiences is that when I point out to the student how he should have responded, without helping him to discover what factors in the patients psychopathology made it difficult for him to respond I do not actually help him; rather, I only leave him feeling more wrong, stupid and inadequate that ever. (Searles cited in Pickvance, 1997, p. 141)

It is important for the supervisor to elucidate and learn to draw out the supervisee's insights - the supervisor's process needs to parallel the supervisee's relationship to the client - in that if they discover how to look and see they will start to see more in the session itself and if they rely on the 'great insightful" supervisor they will not build the skills they need to develop as a therapist. In fact often the supervisor needs to withhold and not offer or give the insight, they need to draw out the questions and insight from the supervisee themselves.

Strategies to address the challenges

Given the potential range of challenges that may emerge in supervision – what are some of the resources of an art therapy supervisor? Just as when one is traveling, if something unforeseen comes up, it can be treated with interest and as an opportunity to learn and gain some new knowledge. Perhaps one might sit down and paint the new landscape or write in one's journal. Art making in supervision can be helpful to by-pass defenses and to access more of the under lying unconscious components of the issue. Exploring the metaphors used or experienced can be helpful. Staying aware of the dialectic and introducing the concept into supervision can

help in shifting the view point and to support the supervisee in observing the polarities and the relationship between the figure and the ground in terms of both the artist/client and supervisee relationship and the parallel process with the supervisee and supervisor relationship.

A useful strategy for issues amongst colleagues is to have both individuals listen to the other and reflect back exactly what they have understood before going on to give his or her own response.

In group supervision with interns co-facilitating art therapy groups co-facilitation issues are not uncommon. Utilizing a structure for the presentation of concerns can help in defusing personal accusations and issues. While it is important to explore transference reactions there are also current concrete concerns and the following three steps can be a useful format for working with issue and dynamics that can emerge amongst colleagues and co-facilitators.

> I see – state the observed phenomena;
> I feel – identify the authentic personal feelings;
> I need – learn to ask for what is needed.

Then it is important to also explore the roots of the emotions expressed by the supervisee. This can aid in identifying transferences. Listen for the metaphors and explore associations. See the chapter on Past and Present relatives and the exercises pertaining to transference.

Serious clinical concerns

If the supervisor has serious clinical concerns regarding the competence or emotional stability of the supervisee or if the clinical relationship between the client and the supervisee has broken down, the supervisor may need to intervene with the client and refer on to another supervisee or therapist. Or if the reputation of the agency or school is at stake one may need to take over the therapy and direct the trainee more closely or remove the trainee from the clinical placement. In these circumstances the parallel process of the clinical relationship of the client to the intern and the intern/supervisee to their supervisor needs to be examined if there is a breakdown in one area there is likely a breakdown in the other. While problems may emerge, there are processes to explore the issues, work through the dynamics and resolve concerns. It is always preferable to understand and work through concerns but sometimes if one meets an impasse, the

supervisee may need a different method or model of supervision and should be transferred to a different supervisor or be removed from the clinical position. It is not ethical to continue for a prolonged period of time in a supervisory relationship without the development of a working alliance (Schaverien, 1992) especially if the supervisor loses confidence in the supervisee's work.

Exploration of Containment in therapeutic presence

Art making exercise: focus on therapeutic presence and the experience of containment. Paint two images: 1) starting contained and then becoming uncontained and 2) starting uncontained and then making it become contained. Then write a description of the two paintings using the phenomenological writing method and distilling themes and metaphors to discover essence referred to previously. Share the artwork and writing. (Carpendale, 2009)

9 MEETING DIFFERENT CULTURES ON THE JOURNEY

There is little risk in becoming overly proud of one's garden because gardening by its very nature is humbling. It has a way of keeping you on your knees. (Joanne R. Barwick)

On the journey we will come in touch with many different cultures within families and communities. The word culture comes from Latin roots of cultivation and care pertaining both to the cultivation of the earth and the cultivation of "mind, emotions, manners, taste," which leads to culture referring to "the concepts, habits, skills, art, instruments, institutions, etc. of a given people in a given period" (Webster's New 20th C Dictionary, 1975). All cultures around the world have scientific /biological and symbolic approaches to healing.

When traveling in other countries spending time in different cultures we are always seeking to understand and to make sense of our impressions. We compare our experience to what we know and are familiar with. We are respectful, curious, and trying to make meaning. It is through this process of making meaning that we are always making interpretations all the time – of people, behaviour, tone of voice, etc.

A social constructivist perspective looks at how our responses are conditioned by culture and how culture affects all aspects of life. As art therapists and supervisors it is important to be aware that our cultural background may affect our practice. There are a number of significant authors who have written about cultural considerations in the context of art therapy and counseling and it is not my intention to duplicate these resources. A key text that I use is Pamela Hays (2001) book Addressing Cultural Complexities in Practice: a framework for clinicians and

counselors. Hays introduced the ADDRESSING acronym for looking at multiple levels of culture. ADDRESSING stands for:

- A - Age and generational issues and experiences
- D – Developmental stages
- D - Disabilities
- R - Religion and spirituality
- E - Ethnicity
- S - Socio-economic class
- S - Sexual orientation
- I - Indigenous heritage
- N - National origin
- G - Gender: male, female, transgender. (Hays, 2001, p. 5)

Developing sensitivity as a culturally responsive art therapist requires a two-fold approach: a) to understand and value one's own culture, beliefs and world view; and b) to have cultural awareness of the clients' culture in order to understand their deeper issues and world view perspectives (Hays, 2001, Moon, 2000). Hays identified some qualities for a culturally sensitive therapist to aspire to as: humility, charity, veracity, and compassion (2001). Obstacles to compassion include defensiveness, fear, ignorance and lack of awareness of cultural influences, emotional pain regarding cultural issues, emotional upsets, hurt & anger, and the therapists' concept of health and theoretical orientation.

To practice in a culturally sensitive manner an art therapist needs to be aware that culture is always an aspect of the therapeutic relationship and that it is important to name it. Minorities often experience hostile, demeaning or patronizing projections. There may be assumptions of stupidity. In the face of prejudice being expressed in-group – while the therapist or supervisor may think that it is not his or her role to take sides – it is very important for the emotional safety of the group to not allow discriminating or racial comments. It can be empowering to acknowledging difference.

Art therapists and supervisors need to be aware of and sensitive to clients and supervisees cultural backgrounds and take the time to understand or research culturally specific meanings that may appear in the art. Hays (2001) emphasizes that it is the responsibility of the art therapist and supervisor to learn about culture and to be aware of its impact in both the client therapist relationship and the supervisee supervisor relationship.

The phenomenological method creates a framework for art therapists and supervisors to stay cognizant bias and inherent assumptions regarding their perceptions of the client or supervisee's art and behaviour. From inside a culture may things just appear as the 'norm' and the 'way things are.' North American Caucasians may have the feeling that they don't have a culture or that the culture is so all pervasive that it doesn't need to be looked at – the invisible "normal" culture. Yet there are many contemporary cultures such as: mall culture, drug culture, different kinds of music cultures, hippy culture, new age culture, youth culture, to name a few.

It may be difficult to escape all of one's biases and prejudices but hopefully we can develop the awareness to think critically and to recognize how we may slide into gray areas. In general, people are more careful with a culture that is clearly different that their own.

Dominant cultures give a sense of privilege or entitlement and minority cultures tend to be cultures that have been oppressed or discriminated against by the larger dominant society (Hays, 2001). Within this context is important to be aware of the privileges held by dominant cultures. Art therapists and supervisors should be aware of how problems and dysfunction develops in a socio-cultural context. The cultural context can influence the particular nature and form of the dysfunction as well as what constitutes normal behaviour (Moon, 2000). In the context of supervision the supervisor needs to discuss with the supervisee how to develop treatment plans, design groups and interventions that are appropriate to working with people from different cultural backgrounds (Moon, 2000).

Personal world views are culturally defined and this includes ideas of what constitutes what it means to be normal and healthy. The artist/client comes into the therapeutic experience with a cultural world view and internal personal beliefs. The context and perceptions of the problem by both the client and significant others are key components to consider. It seems self evident that to perceive and understand the client's culture and worldview we need to be aware of and understand our own. Without this awareness we are at risk of imposing or assuming our worldview is the "way things are". It is important to remember that truth per se is subjective. There is always a danger of 'cultural imperialism', paternalism or colour blindness.

A social constructivist model of supervision can be of value in working with issues of race and ethnicity. Individuals from a minority race or ethnic group - who are not in the dominant culture – may have had formative

experiences of cultural identity that included racism. Colour and race cannot be ignored. Issues of colour and race may be split off or projected in the context of art therapy supervision colour can be symbolically and metaphorically explored. The phenomenological method is helpful in reminding one to bracket assumptions and to take the opportunity to explore all aspects of self (negative and positive). This would include overt and covert racism. Internalized racism may be present as a form of self-loathing and self-blame or blaming the problem on poor body image and race or culture. Internalized oppression may make it hard to explore negative feelings about self and culture if he or she feels that the need to defend a positive view of his or her culture (Ferrara, 2004). A client or supervisee may feel the need to speak as a representative of his or her race. Anti-racism training can be helpful for uncovering unconscious assumptions.

A supervisor will experience different cultures in the context of art therapy supervision. Each culture will symbolically have different languages, customs, kinds of home, architecture, sacred spaces, foods and nurturance, clothing and adornment, music, landscape, work, history and museums, folklore, concepts of self, environment and relationship to nature, beliefs and world view, ideas of family, ways of showing respect, art and symbols, literature/poetry, courting practices, sexuality, intimacy and romance and relationships. Listening to the client's or supervisee's descriptions of life style, home, family and world view, in terms of the different cultural interfaces present bring new awareness to dynamics present. The historical context of the client and the supervisee is important to bear in mind.

A current cultural aspect evident in the youth groups is the experience of 'growing up digital' – cell phones are in constant use, and internet relationships are developing. Risks for abuse and bullying are increasing in a variety of ways.

Thinking about different languages would include not only actual spoken language, but also, sign language, body language and gesture. The supervisor needs to stay aware of different cultural beliefs and difficulties in therapy and in education. Supervisees' may have been raised to obey their elders and have learned to suppress independent thinking. Education and therapy encourage inquiry, challenging ideas and concepts. Each individual client and supervisee will have different cultures and each family system will have a variety of overlapping cultures, likewise each community network.

The kinds of foods that are eaten in different cultures could be thought metaphorically of as the different forms of nurturance each individual might seek. I remember in training as an art therapist, how Dr. Martin Fisher spoke of a couple thinking that the other didn't care for them when he or she was ill. And really, it was that each brought what they liked and were used to having at home when they were ill. One wanted chicken soup for example – and the other wanted something else. Offering tea to one may be well received and another client/supervisee who doesn't like tea will not feel seen or understood. Perhaps they drink Coke Cola which is something the therapist/supervisor never serves.

In the client/supervisee relationship and in the supervisee/supervisor relationship interpretation of clothes, hair style and adornment can either support and increase rapport or cause anxiety and feelings of alienation and difference. Feedback from one senior facility was that some of the male elders from a pre WWII era felt that the art therapy interns in what they called "tights" (stretch pants) were not professionally dressed.

I am aware of my own bias, that likely comes with my age and I am guilty of cultural bias against certain hair styles, clothing, and adornment - for example it is currently the culture in my community to wear considerable 'metal' ornaments on the face and I might question the professional presentation of self in a clinical placement. Clearly with some youth groups or on the street this could create rapport. But the supervision question is what is the intention of the supervisee with his or her physical and professional presentation of self and how will it be interpreted in the placement. In small towns and rural communities art therapists and art therapy students need to be aware that they can meet clients, clients' parents or other professionals on the street, at the store, or at cultural and social situations and their presentation of self needs to be congruent. In supervision – professional identity is a significant area to explore. Supervisees should consider what they are expressing to their clients and learn to think about the use of style to communicate and not to limit relationships or to elicit assumptions. A basic ground rule is to consider the potential impact of unconscious interpretation by clients and professionals.

The therapeutic art studio or office environment creates a culture – is it a creative space – inviting or intimidating. Is it overly clean and organized or merely a mess? Are the materials uncared for or badly presented? What is symbolically represented or communicated as the level of care that the client might expect to receive? Is there art work on the walls? What does it communicate? Does the space invite creativity and permission to explore?

In looking at the social construction of the self, there are noticeable differences in culture. In North American culture there is the notion of an individual self in relationship to family, but the sense of community roots are not as evident as in years past. It is generally accepted concept to view aboriginal people as having a self constructed in family and in community. Ferrara's research on the Cree people "explores the Cree notion of the composite self, which consists of the individual autonomous self, the self-in-nature, and the self in collectivity. The Cree self is reciprocally embedded in the individual, in nature (i.e. the bush), and in the collective (i.e. the community)" (2004, p. 3)

The term 'ecological identity' refers to the ways that a person links their individual identity with nature and to how we extend our sense of self in relationship to nature. Environmental crisis affects clients, particularly the youth. It can acutely contribute to their feelings of betrayal and mistrust of their 'elders'. The environmental crisis is also a cultural crisis as human society is losing touch with nature. Human beings have engaged in behaviours that are destroying our ecosystem and threaten the sustainability of our survival as a planet and as a species. Human beings are the only species that are known to systematically be destroying their own environment. As the world faces increasing environmental threats young people may feel that the adults who were supposed to create a good holding environment – have not done so and thus have compromised their safety.

Although I tend to favour a growth model in terms of therapy, the metaphor for unlimited growth as a model has some inherent problems from an ecological perspective. All cycles of nature have beginnings, middles and ends: periods of intense growth and periods of rest or dormancy. Essentially, it is important in therapy to explore the metaphors for healing that the individual uses and to find ways to enhance or amplify their vision of health. In some cultures, like the Asian community, there can be the cultural belief that problems should be kept within the family.

If we see a client or family as an ecological system then we need to see how the system functions and how each element works with the others. The ecological model can also be applied to an individual through viewing the personal cycles and flow between different aspects of the self and then it can take the larger context of family, to community to culture and environment. Using an ecological metaphor one might see if perhaps an invasive weed is not allowing the natural growth of native plants. Perhaps invasive plants can be seen as parts of the self that eat uncontrollably and don't allow other parts to grow. There is a need to cultivate a connected

self: to move from being split off and separate to being able to engage intimately with others and other species.

Therapy or using an ecological metaphor 'restoration' has a shadow side – it needs to work with the needs and rhythms of each particular place. Rushing a process or taking out too much at once can undermine the healing process. The ecological context shows how all the elements need to work together.

Art therapy encourages the telling of stories – life stories. There are dominant discourses and constant interactions which function to construct identity. A narrative approach to exploring cultural difference and awareness with supervisees can provide an opportunity to "re-story" or to encourage multiple meanings to stories. Therefore it is therapeutically advisable to privilege the telling of stories thus creating opportunities to "re-story". In some sense one can see the art therapist as conversational artist for the re-storying of experience.

Some basic concepts are that meaning is not a given but created in dialogue and art therapy offers the opportunity for new kinds of dialogues (Calisch, 1998). It is important for the supervisor not to take a viewpoint or position of authority in terms of knowledge or objectivity. There will always be multiple meanings of subjective lived experience. The artist/ client needs to be seen as an expert in his or her own experience. Respect between the supervisor and supervisee is integral to a positive supervisory relationship.

Looking for strengths and health can avoid the pathologizing the "other" and the supervisor can encourage the supervisee to look for signs of adaptation, survival, and achievement. Be cognizant of the influence of media on cultural identity and stereotypic ideals of cultural beauty.

In applying a hermeneutic phenomenological method to increasing awareness of culture in art therapy supervision I suggest keeping in mind the five key concepts of description, reduction, intentionality, world context, and essence. Description would include the presented aspects of culture like the age of the individual, implications with the psycho-social stages, developmental stages, and disabilities. In the reduction, where one is bracketing assumptions and trying to put aside any taken-for-granted concepts, it is important to consider what some of the assumptions might be. Often our world view beliefs are so embedded that we need to take them out, name them, and consider the implications, before we put them aside to see with fresh eyes.

The "universalist" position looks for the commonalities of biology and maturation rather than the specifics and differences of culture (Falicov, 1995, cited in Roy, 1999). While hoping to be a positive and inclusive normalizing belief this position can lead to 'colour blindness' and confusions regarding specific cultural behaviours, practices or world view (Roy, 1999). It also doesn't take into consideration the impact of history and the social construction of the self in relationship to family, community and society. While dominant and privileged cultures may take the view that this is treating all people as equal the lack of recognition of the impact of oppression, colonization, and political conflict, can have a tendency to devalue the individual's sense of self and experience in the world. This is not to say that there are universal truths – such as – the parental care for children – however, this may be communicated in different ways. Native people were thought to not care for their children when they weren't physically demonstrative leaving them at the imposed residential schools.

It is equally as problematic to assume that the key factor or difference is the ethnicity, and to work from the assumption that a particular cultural or ethnic group shares more than they actually do. It is important to learn about the different cultural behaviours and beliefs to avoid responding in what would or could be experienced as intrusive or 'rude' (Falicov, 1995, in Roy, 1999). Some examples are: a native person will respectively give a light handshake while a white person will give a 'hearty' or 'firm' handshake. Eye contact and direct gaze is another area of difference in communicating respect: Caucasian white culture emphasizes the direct eye contact whereas oriental and native cultures do not. Voice tone and comfort with silence is also different. "Indians know how to listen to silences. Whites are panicked by silences." (Pelletier & Poole, 1973. p. 39)

A 'particularist' position stays focused on the uniqueness of the cultural construction of each individual and family system. However, this may not take into consideration the external factors and aspects of culture and socio-economic realities (Falicov, 1995, in Roy, 1999).

Hays (2001) exploration of the complexities of culture really helps in preventing the reduction of culture to ethnicity, indigenous heritage or nationality. The inclusion to consider cultural aspects of such things as age, disability, gender, language, place (rural or urban) and socio-economic class, broadens the concept of culture. This 'multi-dimensional' position (Falicov, 1995, in Roy, 1999) avoids a reductionist perspective by opening the definition of culture to view people as having a number of different

interfacing cultures thus avoiding stereotypes will still being cognizant of the cultural implication. (Falicov, 1995, in Roy, 1999).

Interpretative practices and symbolic tools that can be of value while traveling in different countries and cultures. Hermeneutics, as previously discussed, pertains to a symbolic practice of interpretation that is trying to understand the "lived experience" (Van Manen, 1990) of the individual, while moving from the part or specific and back to the whole. In terms of the cultural aspects one is going to be approaching the uniqueness of the individual experience and reflecting on the larger implications or place in the whole – with considerations of varieties of cultural interfaces as outlined in the ADDRESSING acronym (Hayes, 2001). The attitude of a phenomenologist is helpful as one is attentive to the pre-reflective description of the "lived experience" while bracketing one's assumptions. As discussed previously the phenomenological method and the deep internal practice of 'reduction' functions to develop culturally sensitive and responsive art therapists and supervisors.

Issues of age can be a factor in both the clinical work and in a parallel process of supervisory relationship. Age can also be a factor if the supervisee is a lot younger than the artist/client; or if the supervisor is a lot younger than the supervisee. The cultural components of age can include the age of the individual in relationship to the current problem or life situation and it can also refer to the need for the therapist/supervisee to be aware of the historical impact that could be a factor for different cultures and ages. It is important for a therapist to be alert to the historical significance of certain times in history. For example the 1930's and 40's in Eastern Europe will have impacted both Jews and non-Jews re trauma, shame and guilt. The impact of residential schools on aboriginal people will also have affected different generations. In the Kootenay Boundary area in British Columbia, where I live there are a number of historical cultural issues to be aware of. These are some examples:

- The loss of the Sinixt People on the Slocan River due to small pox.
- The interment of the Japanese Canadian people from the lower mainland area during the WWII. There were camps in Lemon Creek, Slocan City, Sandon, and New Denver.
- In the 1950's many Doukhobor children were rounded up by the RCMP and taken for schooling in a compound in New Denver. Some were held for up to six years before being released. This was due to unrest from the 'sons of Freedom' sect,

who were resisting being disenfranchised by the government. Doukhobor, means 'spirit wrestler' and they immigrated from Russian where they were persecuted for their pacifism and simple Christian life style.

• There is a history of changing laws and treatment of the native people in Canada, which includes the creation of reserves, the enforcement of children attending residential schools, the sixties 'scoop' when many aboriginal children were taken by social workers and put into white foster homes. It wasn't until the 1960's that the native people were allowed to vote and to attend high school.

Considering the cultures of age in art therapy supervision might also pertain to the age of the client in relationship to the age of the supervisee or the age of the supervisee to the supervisor. Being the same age or older or younger in one role or another can definitely be a cultural factor in the relationship dynamic. Staying curious, reflective and not making assumptions will help.

Issues of class can be evident in art therapy supervision. They may impact the supervisee in his or her perceptions and assumptions regarding the client. It has been said that it can be more difficult to talk about money than sex. Class pertains to the social means for production. It includes money (wealth or culture of poverty); the sense of entitlement and expectations of life; worldview and life view; life style and consumption / vacations / choices; self esteem; work ethics/ employment; education; and language and opportunity.

Socio-economic factors influence the development and treatment options for individuals living with mental illness. Suicide and abuse is influenced by work problems, economic stress and unemployment.

Working with a translator in art therapy the supervisee and supervisor may be unsure of the actual / literal / emotional interpretation. Therefore it is important to pay extra attention to the nuances of communication and to be responsive to body language, eye contact, tone of voice, gesture and response to the translators return comments to the client. I have found it helpful to listen closely when the client or supervisee is speaking in his or her own language to listen to the emotional component and then to listen to the translation. The absence of a common language can function to exclude people but artwork can be seen and responded to by all. Perhaps it may be important for the art therapist to respond with a work of art.

Supervision is an opportunity for teaching critical thinking. In critical thinking one must always keep track of the figure ground relationship and the relationship of the narrative to the context. This is particularly important regarding cross-cultural issues or different social classes. The client's context may be quite different to your own. The phenomenological method helps to discover the essence and to not become lost in the narrative.

Some suggestions for enhancing culturally sensitive and responsive art therapy skills in supervision:

- Welcome diversity – include different cultural perspectives.
- Build awareness of the many aspects of culture and value cultural memories and experiences.
- Discuss theory critically - considering the relevance for different cultures.
- Name and address racism, classism, and inequality clearly and consistently.
- Include socio-economic and psychosocial perspectives.
- Explore images from a range of cultures with regards to meaning and symbolic significance.
- Expose supervisees to knowledge regarding different cultures – re art and concepts of healing.
- Don't let a student feel responsible for educating others about race and culture.
- Respect student's cultural expertise in clinical work.
- Create a learning environment that builds on human experience.
- Art therapy supervisees need to explore the implications of his or her cultural background.
- Introduce culturally appropriate art therapy models – like a phenomenological orientation.
- Be adaptive to culture regarding art therapy practice.
- Be less 'precious' regarding traditional concepts of the 'right way' of doing art therapy.
- Introduce a practical 'hands on' approach to supervision.
- Utilize role-play with sensitivity to increase understanding of race and culture.
- Healing rituals, ceremonies and stories can be incorporated into an expressive art therapy practice.

Cultural Activities

- Family trees: make one with a focus on exploring the different roots of culture.
- Cultural symbol book: create a journal / scrapbook exploring different cultures. Include symbolic interpretation, world views and different theories of change and therapy.
- Tell a story about your name as an opening introduction in a group can bring to light a lot of cultural background and beliefs.

10 Stopping to Paint on the Journey: Art-Based Supervision

We propose that image making is another, alternative way of formulating and communicating this emotional experience (Brown, Meyerowitz-Katz, Ryde, 2007. p. 168).

The engagement in the creative process adds a unique dimension to the supervision process. The concrete and tangible aspects of art making provides both metaphorically and functionally an opportunity for the supervisee to take an active part in their supervision; they are responsible for their growth and development; for the issues brought to the fore. Art making like gardening or being in nature provides sensory stimulation and kinesthetic pleasure, which activates memories and connects feelings to sensations in the body, thus providing an opportunity for integration between the psyche and the soma, not only for maintenance and restoration but also for re-creation and making the garden in a new way. Using the metaphor of the garden as a therapeutic space the supervisees are engaged in digging the garden, in choosing what to plant, when to plant and where to plant.

> Image making as part of the supervision process can enhance the work by acting as a container for anxieties and the inexpressible. It can function as a metaphor for both individual and group processes and as a metaphor to reveal more of the patient's internal landscape. (Brown, Meyerowitz-Katz, Ryde, 2007. p. 179)

The creative process and interactions with art media can give the supervisee an opportunity for expression of difficult to articulate emotions

and allow for latent unconscious content to become manifest and available for new understanding and insight. There is the opportunity to dig into the past, to transplant and remove or move plants. Issues can be seen as underdeveloped aspects that need an opportunity to grow – perhaps they need more light, or water or room.

Engaging in the creative process helps to give expression to simultaneous feelings and to work with conflicting and ambivalent emotions. In a garden even when we weed in one area we can see this area in relationship to the rest of the garden and weeding is not just about taking out "bad" or "wrong" plants sometimes there are just too many plants in one area or some plants are not allowing other to grow because they are overshadowing them.

Art making provides a concrete opportunity for problem solving and empowers the supervisee in their supervision process. The engagement in the creative process and process of looking at the art encourages the awareness of metaphoric meaning and allows for symbolic meaning to become transparent and available for the individual to perceive and thus to develop insight. Extending the metaphor of art making, the use of art making in supervision serves to empower the supervisee in understanding how to self reflect and problem solve for themselves. This is an important skill as supervisees move into their professional roles.

There are several important functions of introducing art making in supervision (Kielo, 1991, Carpendale, 2003, 2009, Brown, Meyerowitz-Katz, Ryde, 2007, Riehl, 2010):

- To develop empathy with client
- To clarify feelings
- To encourage visual thinking
- To explore the unconscious and preconscious
- To contain emotion and express anxiety
- To examine affect
- To explore the therapeutic relationship
- To explore transference and counter transference.

Just as the therapeutic setting can be seen as framed space, a potential space, and a sacred space so can the supervisory space. The supervisory setting is framed by the actual physical environment and by the time constraints of the supervisory relationship. The framework serves to create a safe space to express, to process and contain feelings. It is intended as space for meditative, creative, self-reflective experience.

Creating artwork in the context of supervision whether it is done as post session art or as art based supervision also can serve as a framed experience. The boundary of paper and materials mark it as separate from the environment. The completed work can be viewed as separate from the creator. Looking at the artwork of the artist/client and looking at the artwork of the supervisee may reveal unconscious content. The content of the supervisee's artwork may be experienced as being overwhelming, exposing and/or revealing too much. The supervisee's artwork may reveal transference and counter transference dynamics as the issues emerging may pertain to feelings of being seduced or repelled by the client's artwork, comments and behaviour.

The opportunity to look at the artwork in supervision and to have a retrospective review is a therapeutic and supervisory aspect not available in verbal therapy.

The Life of the Artwork

Schaverien (1992) discusses how the life of the artwork corresponds to the therapeutic relationship. The artwork interacts with both the therapist and the client just as they interact with each other and the artwork. Some of the aspects to be considered are the effects of the picture when it exists as an object:

1. Duration of its life: short term or long term (could include post-session art).
2. Emotional response and interaction: intensity, dialogue, meaning.
3. Influence in the therapeutic and in this case supervisory relationship: role in therapy -significant or insignificant.

Stages of the Life of the Artwork

Schaverien's (1992) concepts regarding the life of the artwork pertain to art therapy supervision in a number of ways. Schaverien's stages and processes regarding the 'life of the artwork' (1992) have been extended here to include artwork made in the context of art based supervision.

First of all there are the non-verbal stages, where there is the interpretation of self to self:

- Creative process – making the artwork.
- Identification with the artwork: the meaning and the image are undifferentiated and inseparable.
- Dawning of conscious understanding of the elements in the artwork; beginning separation from the identification with the image.

Secondly there are the verbal stages with the interpretation of self to self and self to other:

- Words come into play with the artwork and words tend to "fix" certain meanings and exclude other possible meanings.
- Ambiguity of meaning and the possibility to take on new meanings. The artist client needs the image to remain ambiguous and not take on a 'fixed" meaning.
- Verbal interpretations or interventions may:
- arouse resistance, which will oppose the attempts to bring meaning to consciousness; or
- reflect understanding and deepen the experience;
- The interpretation process revolves around the artwork once it exists.
- When the timing is right the connecting the words to the image or giving voice to the artwork can help to bring insight.

Process of the Life of the Artwork

The process regarding the 'life of the artwork' relates to the artwork made by the artist/client and also the artwork made by the supervisee. The following aspects outlined by Schaverien (1992) all pertain to the lived experience of the supervisee as a witness, participant, creator and presenter in the context of supervision. While the supervisee in the role of art therapist may function as witness and be in a more 'passive' position in terms of 'holding' the space, he or she becomes more active in presenting the artwork and looking at it in the context of supervision. The five aspects are not intended as a linear code but as a description for processes and practices that are not necessarily linear or sequential in form.

- **Identification**: sympathetic connection in viewing the image.

- **Familiarization**: the artwork is viewed as outside the self and there is a process of conscious recognition of what has been split off and projected into the artwork.
- **Acknowledgement**: there is dialogue regarding the conscious and unconscious aspects and implications of the artwork.
- **Assimilation**: there is integration through contemplation of the artwork.
- **Disposal**: the decision regarding the ongoing life of the artwork or the method of disposal may illicit counter transference reactions from the therapist. The artwork may be considered a symbolic talisman and continue to be honoured and framed as an empowered image. Or it may be seen as a scapegoat and be destroyed or discarded as a completed part of the therapeutic work.

Art Exercises for Supervision

Directive: Do your own art spontaneously. Allow feelings and thoughts to emerge.

Directive: Draw like your client. Use the same media. Try and duplicate their style. Reproduce what they did. In some sense the "mind of a persona can be understood only by reliving its workings" (Polyani, 1967, p. 16) and the process of developing empathy or 'indwelling' can be enhanced by recreating the art of a client in the media and manner of which it was made.

Directive: Reproduce a client's drawing in the media and style they used. Do another drawing that you think they would do if they were well. Do one small improvement on the first drawing that would be a small step towards emotional health. (Kramer workshop – using the third hand)

Directive: Draw/paint the colours, shapes and movements that would express your experience of the client.

Directive: Draw your ideal client.

Directive: Drawing of self with a client.

Directive: Drawing a symbol of self and drawing a symbol for the client.

Directive: Relationship mandala done as a clinical relationship. (Tobin, 2008, Carpendale 2009)

Directive: Use post session art making to respond to a session or give expression to feelings arising from a session. Have a sketchbook to do post session art in.

Directive: Create art in response to a disturbing image.

Directive: Make art to express the metaphor you have for therapy and healing.

Getting to the Underbelly
(Carpendale, 2003, 2009)

This exercise can be used to explore any therapeutic issue, clinical concern, or any aspect of transference or counter transference. It involves the creation of art in response to the specific concern. This can be done as post-session art, preparing for or during supervision. The intention is to provide a framework to "unravel knots" and gain a better understanding.

The method is contemplative and meant to illuminate essence not to establish scientific fact or causality; so the steps in the process, as given, are not meant to be a recipe wherein the steps must follow each other in a specific order. Rather, the key concepts are meant to be used as reflective foci from which one can move forward and backward using each to throw light on the others. For example, while reflecting upon 'Intentionality' one may become aware of assumptions that crowd in the mind and distract one like the sounds of crows cracking walnuts on the tin roof outside one's bedroom window. While reflecting upon these assumptions, one may become of aware of the overall context of the situation and from this awareness may grow an intuition of essence.

In general, the process involves the making of 5 pieces of art. The suggested art materials are simply drawing paper, oil or chalk pastels, pencils, or felt pens. Of course other material can be used but the intention is more for the immediacy of emotional and symbolic expression.

The purpose is to explore, as fully as possible, the supervision question through the lens of each step of the phenomenological method. After making each piece of art, sit back and have a look. Get some distance and reflect. Write about it. Aim at an accurate description of what you see in the art. You may

want to underline key phrases and note associations. You may want to write a poem (especially concerning your work on essence). Remember that essence will be discovered by intuition. Move back and forth between the images you did for each concept. Allow your intuition to connect personal meanings with objective factors. Intuition will integrate the whole process.

The exercise is broken down into its 5 separate components below.

Description: The first piece of art you create is an image of the situation. This might be done in a number of different ways: it could be a realistic narrative depiction or an abstract depiction of feelings, or symbolically as a metaphor or series of metaphors. Just as in creating art in therapy, there isn't a right or wrong way to do it. Put the art up and have a look at it – perhaps step back and get some distance. The focus is on the actual art work. Observe the structure of each image, the figure ground relationships, the interrelated components, the dynamics, symbolism and style of expression. Write a description of what you see. In this step we are looking for a pure description, not analytical reflection, scientific explanation, or any tracing back to inner psychological dynamics. With a premature focus on explanation we can lose the essence of the experience.

Reduction: Make a piece of art about your assumptions. Or write them down. Some of these assumptions will be clarified by your descriptive process. You are trying to put down what you think you know or what other people have communicated to you. The purpose is to record all of these biases & assumptions so that you can set them aside & be able to look at the situation afresh. You might like to try "free writing" (10) writing continuously without picking up your pencil and without editing for a brief period. If one doesn't go through a process of naming one's prejudices, biases, conceits, interpretations, beliefs and therapeutic goals, they tend to lurk around the therapeutic space causing disturbances. These assumptions may become more evident when we are unsure how to proceed therapeutically. In fact, it may not be the client who is stuck but ourselves because we are stuck on an interpretation or particular viewpoint.

Intentionality: Make a piece of art focused on the concept of Intentionality. Explore the motivation & desire of the client & therapist. Explore the meaning of symbols, events, client's art work etc. The intentions of the client will be in direct relation to their biases and assumptions. On

the other hand, the therapist's intention might be important here. More biases & assumptions may come to the fore & then one may wish to return to the second piece of art. Reflect on the art and write about it. Describe what you see and include any and all associations.

Essence: Reflect on the essence of the situation. Create another piece of art that expresses the essential feeling or what you see as the essential elements of the situation. Remember that the essence is discovered by intuiting not by deducting. The conception of essence will be distilled from the description & aided by setting aside your assumptions. Poetry is often useful at this stage. If you are stuck at this step go on to the next step and come back to it when you look at all of the images together.

World: On a new sheet of paper draw or map out all the relevant relationships and place the situation in context. The client does not exist in isolation. This contextual element of the exercise pertains to the contemplation of the personal history, culture, family of origin, significant life events, illness, losses and developmental stages of the client. This step also takes into account cross-cultural and ethical considerations. The client is in the world with fellow group members, family, school mates, and so on. The exploration of this domain may also pertain to the therapist's own role in the world. While this step might involve creating a genogram or sociogram it can also be expressed in a more symbolic and creative manner.

Alternate approaches to the exercise:

There are a number of ways to work with this model, other than the one given above. One single piece of art might be created and then the 5 concepts explored through writing. Yet, another way to approach this exercise would be to focus on the writing first, underline the key phrases, sometimes called 'horizons' and then move to explore the essence in the art. These horizons are key phrases where there feels like the potential of light or insight, or darkness and shadow; there is a gap, a space, a silence, a shout. A horizon is the extent of what one can see from a specific vantage point and to 'have a horizon' refers to one's perception going beyond what is in the foreground and one's range of vision being expanded. In reflection on the image and the writing there may be a movement between one thing and another – a place or phrase that moves and refers to different levels.

A possible next step would be to take the horizons and distill the essence and write a poem.

Reflective synthesis

One might also add a final step by creating a sixth piece of art as reflective synthesis of the five original pieces (Kidd & Kidd, 1990). A further level of insight and integration might be achieved by putting all of this art up together and exploring it in dialogue with an art therapy supervisor, fellow supervisee or colleague.

Student observations regarding the Exercise

The following observations are by two students who used the exercise in order to explore clinical situations. One student reflected on the model saying that for her the 'unraveling' of supervision knots created a format to "look at specifics and also zoom out to broad general ideas and goals." She went on to say that:

> It encouraged me to unearth my assumptions and judgmental opinions, my potential blocks to seeing clearly.... I had a number of pre-decided judgments about the mentally challenged that I wasn't fully acknowledging before I started to interact with them in group. Many more ways to see the individual and talk about her situation/ future/ issues/ needs came out of the process, as compared to what I might have said if simply asked to discuss her. At the end I saw where the 'essential' goals and issues of the client and myself were so much the same.

A second year art therapy student described her experience of doing the exercise. Starting with her description she wrote

> I chose to concentrate on my reaction towards the client's hesitation and my desire to push or squeeze the essence out of her. I also noticed my reaction . . . towards other facilitators and their self-doubt in voicing their ideas. I react strongly wanting to reassure both clients and co-facilitators that 'they can do it' or that 'their ideas are valuable". I wanted to explore this because I sense there

is a danger in me shoving or pulling people to where I think they should be, without allowing others to realize their own potential.

In responding creatively to the concept **reduction** she recognized a number of her own assumptions, included her desire "to pull the outsider in and boost their confidence". She recognized that her own over confident approach may actually increase the client's feelings of self-doubt.

Exploring the concept **intentionality** she recognized her "desire to help, nurture or feed somebody else's self-confidence." She expressed the **essence** of the situation in the image of a snail "because it reflects my desire for patience. The antennae pick up on the feelings of insecurity and hesitation and it immediately moves me to action. This comes out, without having time to process, as re-assurance or ego boosts. I imagine my receptors 'tuning' into it and then allowing the thoughts to spiral into a deep spot first (think before you speak)."

Her image of **being-in-the-world** enabled her "to see the situation in a more whole way." The exercise & the creation of metaphor helped her synthesize the insight that "Pushing somebody into a swimming pool may cause panic instead of the desired swimming skill." She went on to say that she would use her reactions to "zip it, snail style" instead of "pushing my attitude on others."

Summary

I have found this model utilizing the five key phenomenological concepts to be a useful framework for individual or group supervision. Whether one creates art or simply uses the five concepts to verbally or in writing explore a situation, I believe that it can be effective in any supervisory setting. Because many of my graduates have jobs in distant parts of the country where there are no registered art therapists close by, they are meeting their supervision needs in a number of ways: 1) travelling long distances once a month, 2) being supervised by other trained clinicians, or 3) doing email supervision using a digital camera to send images of the art. It was my intention in developing this exercise to provide a framework for self exploration of supervision issues through using art and writing. It is not intended to be a substitute for actual face to face art therapy supervision, but to be another available tool or method for professionals. It is my hope that this model can be useful for individual, peer or group supervision.

11 STEPPING INTO THE SHOES OF THE OTHER

Wonder is that moment of being when one is overcome by awe or perplexity - such as when something familiar has turned profoundly unfamiliar, when our gaze has been captured by the gaze of something staring back at us. (Van Manen, 2002)

Poetry isn't something separate from life. It can be a way of knowing - a praxis or method of self-reflection in the world. Writing as a reflective practice is not about thinking a specific therapeutic or spiritual thought and then writing down what your insight is, it is about actually writing as a process of discovery, of finding out, a way of perceiving in an active practice.

These exercises will be of value to both students and professionals because learning to become fluid in one's perception of metaphor and symbolic meaning will enhance therapeutic perception and responses. Sometimes an intern or therapist talks of the difficulty in opening the dialogue saying "…. but they [the artist/client] only said – this or that" believing that there wasn't anything significant to work with or respond to therapeutically. It is important for expressive arts therapists to have a praxis that helps them realize there is always the possibility of an authentic response that might engage a therapeutic process whether it is silence or words. An authentic response to clear "stop signs" or "defenses" will be respectful as there is always a good reason they are there.

In training to become an art therapist everyone agrees that it is important to work with the materials in art making. It is also important to work with the language, the dialogue, the metaphors and culture created in the therapeutic space. We could take a word like 'trigger' or 'fragmented' or 'off centered' or 'lost' and explore its significance and we would never

exhaust its meaning but through a phenomenological method perhaps we could distill the essence.

There is no one place that we need to arrive at in therapy. There is only the need to get to that place of discovery – that place of renewal – that sense of being alive – that place of making meaning of life – of making connections with the world – with words – with others. It is also important to be witnessed – to hold that both loss and love are both within and can be carried into the present.

To be able to have a praxis of reduction we must allow the flood of inner thoughts and connections some air to breathe – to get to know them – to see how the words and metaphors can actually open up the whole universe.

Emotional pain is often expressed through metaphor - sometimes as a wound, disease, baggage or garbage. In therapy one might refer to feeling like being in the deep freeze, a flower unfolding, or a baby being born. The growth metaphor is interesting and commonly used. If we amplify the idea of growth there will be differences if we look at the growth patterns of a plant or of an animal. What does a plant need to grow? Good soil, nutrients, water, sunlight and a conducive environment are all important. What if it has too much water like say a tree in water? Could there have been a flood? If the tree looks strong and has some green leaves but has water around its roots it may indicate that it is under present duress but has been recently strong and growing. Some plants require pruning and some have dormant periods in the winter.

A cautionary note: symbols and metaphors are multi-leveled and cannot be reduced to single meanings. When it is a symbol it speaks infinitely and when it is constructed into words, it becomes limited. Symbols and metaphors can grasp a whole number of aspects in one more or less simple formulation. It is important to see metaphors on a continuum or dialectic with positive and negative aspects.

Essentially the phenomenological method is practiced through writing. Van Manen (2002) writes that "Phenomenological research does not merely involve writing: research is the work of writing - writing is at the very heart of the process." He goes on to say that "Something happens in the act of phenomenological writing: phenomenological writing is the very act of making contact with the things in our world." Phenomenological inquiry is based on the idea that no text is ever perfect, no interpretation is ever complete, no explication of meaning is ever final, and no insight is beyond challenge. It reminds one to remain as attentive as possible to the ways

that all of us experience the world and to the infinite variety of possible human experiences and possible explications of those experiences. (Van Manen, 2002)

In a writing praxis for self-exploration or self-supervision the focus is to open the heart, mind, ears and voice. The intention is to let perception flow and to disrupt the conventional view of "the way things are" and to give insight and voice in "the way things could be". It is only our perceptions that can change the way we experience the world and thus can actually change the world. There is the metaphor or a saying that asks "Is the cup half empty or half full?"

Writing Exercises

Paying attention: In the beginning one must pay attention through all of one's senses. The senses include visual perception, auditory perception, scent, taste, touch and internal sensations. It is important in paying attention to not reach for the first information but to allow one's sight and mind to be relaxed and achieve a diffuse gaze. Writing as a reflective practice is not about thinking a spiritual thought and then writing down what your insight is, it is about actually just writing as a process of discovery, or finding out, a way of perceiving in an active practice. The intention is basically to practice free writing in the way that one would free associate to an image, idea, sensation, or feeling. Let the words flow, and flow is a key word, let all the words and thoughts come onto paper, remember that the creative process and the spiritual process is about discovering what is and then allowing meaning to emerge through an interpretative practice.

Free writing: is like free association – opening to the world that floods us and writing without stopping, without editing. Allowing one thought move to another without irritably reaching after meaning and beauty. Let fairytales and parables emerge, song scraps and nursery rhymes, memories and desires. I find it helpful to work within the limitations of a time frame as it puts a certain pressure on whilst it also relieves anxiety that we have to find a 'big insight' or write a 'great poem'. It is just a way of digging in the soil, a way of attending to the tacit knowing.

The directive is that in free writing to start with a description, and don't edit, don't stop writing just write the word over and over again until something comes into your mind. Write whatever comes to mind. Write a description of what you see – what you smell – what you hear – what

you touch – what you feel. If your mind wanders go with it and discover other places. Let lines of song or rhymes come. Write from an "I" voice as if you were the subject. Set a specific time for writing – 3 minutes or 5 minutes or more as you get used to it.

Poetry: How to write a poem - a poem can be a word – or a phrase – or a number of phrases. If you are not sure of how long a line should be – have the line be the length of your breath, as Fred Wah, the noted Canadian poet would say. Put aside any conventional necessity for rhyme or time length – allow the length of your line to be your breath and make a new line for each breath. There might be rhythm or there might be repetition.

The lottery: A reflective phenomenological writing exercise - learning to unpack a symbol. Explore symbolic frameworks through writing and a phenomenological method of examining themes to distill essence. Take a word and write about it for 5 minutes. Discover the horizons. Underline the essence. Write a poem. Read it. Reflect.

This activity can be done in a number of ways. You can start with a word (given or chosen), or image (created or found), or you can focus on interacting in the natural environment. It could start with walking and or wandering around in nature to find an inviting place to sit. It can be done through selecting collage images or painting an inner image, perhaps of a landscape. As a group activity I will write words on small pieces of paper and the participants/supervisees will draw one like a lottery. There are different sets of words that I choose like: weather; animals, gardening, housekeeping.

Words like: oven, toaster, fork, knife, spoon, plate, pot, kettle, cup, glass, bowl eggbeater; animals, (sheep, cow, dog, cat, pig, horse) birds; vehicles, (motorcycle, car, truck, train, plane, bicycle, wheelbarrow, wagon) insects, suitcases, etc. Or all body parts. Examples: fork: something to stab with, to eat with, a forked tongue, a fork in the road, oven: to cook food in, to heat things up, a bun in the oven (pregnancy)

Words like: Rose, thorn, vine, olive, lion, lamb, rabbit (hare), frog, fox, egg, dove, dog, bee, serpent (snake), breasts, goat, eagle, bear, bull, vulture, raven, griffin, dragon, phoenix, sphinx, centaur, unicorn

Words (nouns or verbs): search, dig, refine, refuse, emerge, hide, plant, water, run, burn, blow, clean, wash, sweep, weed, prune, cut, clear,

The words / symbols could be from an image or metaphor an artist/client used: mirror, tree, dog collar, feather, mask, etc.

Take the same process but use a word to start the free writing on a theme: Cleaning, washing, sweeping, digging, shoveling, eating, drinking, sitting, walking, weeding, pruning, clearing, sorting, mending, planting, picking. Write about duality – good and evil aspects of natural phenomena.

Explore nature, weather and natural occurrences metaphor: fire, water, earth, air, avalanche, storm, mist, ground, waterfall, rapids, clouds, etc.

- Give a voice to each aspect – to fully embody the meaning.
- Try walking in another's shoes or to be the rock or tree.
- Write from the perspective of each image and try to use a personal or "I" voice. This is, I have realized in discussions with Jacqueline Fehlner, very similar to prayer exercises developed by St. Ignatius, whereby one would take a passage of scripture and put oneself into the story and tell it from different perspectives.
- After writing, take some time to read what you have written, underline in colour key phrases, insights, aspects that seem of value. Think of this as looking for the 'horizon' or 'gap' where light can get through. What is the essence of what you have written?
- Reflect and distill the essence. Write a poem. Let a word or small poem – perhaps a haiku emerge.
- After the observations and paying attention, the writing, reflecting, and distilling the essence, it is important to be witnessed. Invite the poems to be read aloud. The intention is to find a voice, an authentic voice. Poems can be read by the writer or the therapist/supervisor can read them back to the writer.

Writing in the natural world - ask nature to speak to you. Look with the eyes of your heart to see what can't be seen and listen with the ears of your heart to the birds, to the wind and water - listen and hear what can't be heard. It is your place to give voice to those who cannot speak our language. It is your role to be a translator, to discover the meaning, to perceive the connectedness and relationships.

Cut up writing: A free association exercise to loosen your conventional framework. Take 2 pieces of random cut out magazines strips (about 1/2 to 1 inch in width and lay them side by side and read across and allow a poem / story to emerge. This is an Allen Ginsberg "cut up" technique. The intent is not about creating a 'poem' as a complete piece of writing / art, but of exploring metaphor through writing and poetry.

Stepping into the shoes of the other: other voices can be created through standing in another's shoes. This could be the voice of another being as a person, a plant, an animal or an object. The intention is to speak from a specific place and to empathize through giving an "I" voice.

Practice phenomenological writing: write a phenomenological description from a magazine image. When you are not sure what to write come back to the image and describe both the positive and negative space in view. Consider the perspective. Be aware of shifting from foreground to background. How are things connected? How are they separate? What are you taking for granted? What eidetic images overwhelm you and blind you to the smaller details like insects for example. Write your assumptions that should be bracketed out. What are the clichés and metaphors that come to mind? What are the negative or shadow aspects that are lurking around? Let your mind roam free and write whatever occurs to you including: memories, word play, associations, metaphors, parables and stories.

- Write using an "I" voice for all aspects of the image.
- Identify themes through underlying words. Highlight 'horizons'. Then we are going to reflect on the "text" with a phenomenological analysis of theme. Read what you have written – listen for gaps – hesitations – horizons – places where the light gets through or is glimpsed – where there is energy or desire.

- Looking for themes can be done by reading the whole text or by going line by line and amplifying the associations in the themes.
- There could be a step where you do a thematic amplification – and you would write from the themes you discover – or there could be a distillation of the essence into a poem.
- Distill the essence and write a poem.

A metaphor for healing, therapy, health or well being: create art to express your metaphor for healing or therapy. Write a few words or metaphors about it. Talk about metaphor theory and conventional metaphor and perceptual or innovative metaphor.

For example, a metaphor that I use is 'juicy' which refers to the liquid in a fruit – the distilled essence that will provide a fluidity or flow of nurturance and energy.

12 VISITING THE RELATIVES: PAST AND PRESENT

... the realization that knowledge was not the comprehension but the construction of an object. Knowledge was not a given but a task... (Lipton, regarding Cassirer, 1978)

On the journey there will be relatives to visit both past and present. Feelings and behaviours that are an echo of past relationships can emerge in inappropriate ways. There can be a feeling of déjà vu as emotional patterns repeat. This chapter will discuss transference, counter transference, projective identification and the therapist's ego investment needs. Transference is a concept that has been applied in psychoanalysis to provide structure and language to an inner experience. It refers to the unconscious 'transferring' of intense emotions that originated in the past and are brought forth into the present and often with the individual acting on these feelings as if they were real in pertaining to the individual. These feelings originated in the individual's early life and generally were previously experienced in regards to members of the family of origin. While transference is a common occurrence in the client therapist relationship, it is essentially a form of projection that occurs in many situations not just therapeutic relationships. Transference is not a bad or wrong aspect of therapy – it is an opportunity to grow and change. The awareness of and working through of transference is fundamental to training as an art therapist. Essentially the transference refers to affect/emotion from the past coming alive in the present. Remembering and exploring the symbolic nature of the transference is central to the therapeutic process.

Casement writes

> because there is no sense of time in the unconscious, anything in the area of overlap can be seen unconsciously as belonging equally to the past or to the present. It is this misperception of similarity as sameness that brings about the phenomenon of transference, whereby previous experience and related feelings are transferred from the past and are experienced as if they were actually in the present. This is why the phenomenon of transference can have such a sense of reality and immediacy. (1985. p. 7)

The attention to the desire will help to bring unconscious impulses to consciousness. Freud believed that the patient's desires should be allowed to come forth, but should not be satisfied or gratified. Resistance can emerge in acting out in the transference or in the gratification of desires. This would repeat in real life what should be remembered and worked through.

While transference in essence refers the intensity of the relationship that has activated the internal objects of past 'relatives' there is also a very genuine relationship between the therapist and the client. This 'real relationship' includes the humanness of the therapist with strengths and weaknesses. There is a dialogue and authenticity between client and therapist – that holds the therapeutic frame. (Greenson, in Schaverien, 1992) There is also a 'therapeutic' alliance which is based on trust and respect and is essentially an agreement to work together to observe and work through the transference. (Schaverien, 1992) These three elements: the real relationship, the therapeutic alliance and the transference are all important aspects of the client therapist relationship (Schaverien, 1992) and they are also important aspects of the supervisee/supervisor relationship.

The significant characteristics of the transference are repetition, inappropriate emotion and behaviour, and ambivalence. (Greenson, 1967, in Schaverien, 1992) As in all things – we don't get light without the shadow and there are always negative and positive aspects to the transference, one may not be so evident, but stay aware. If there is no negative transference the patient may be splitting and focusing their negative feelings elsewhere. Negative feelings may be focused outside of the analysis due to fear of damaging the therapist or the therapist's responses and/or counter transference may be preventing the expression of emotion or recognition of some rage.

We all try and understand the world through the lens of our own understanding. The concepts of transference and counter transference can lend insight into therapeutic work. Acting out in the transference refers to when an individual starting acting towards an individual as if they were that person or more as if they had all the attributes of the individual. It is when through a small similarity – one creates a whole gestalt and starts unconsciously behaving and believing as if they have all the characteristics of the projected person. Transference occurs in educational relationships, employment situations, families and intimate relationships. The feeling that you already know someone you have just met or having an instant response to someone new may include transference feelings. We can take an instant attraction or aversion to someone because of some specific visual, auditory or olfactory stimulus. There are many people that remind us of others but this is not necessarily transference.

Initially counter transference was considered the therapist's response to the client's transference but contemporary therapists tend to consider counter transference to be the sum total of the therapist's response to the client. This includes conscious and unconscious thoughts evoked in the therapeutic relationship.

Szasz introduced another perspective on the concept of transference regarding the symbolic nature of the concept and he identified how this can serve to protect the vulnerability of the therapist in terms of the 'real relationship' (1963 cited in Schaverien, 1992).

Historical development of the concepts

The concepts of transference and counter transference developed in psychoanalysis. Freud initially defined transference as the reconstruction of a past relationship transferred and projected on to the therapist. Freud thought of the transference as unnecessary and in the way of reaching childhood memories and fantasies and he thought that these intense feelings towards the analyst disrupted the analytic work. The analyst became hated or loved and the analytic work ceased to be as important to the patient. Then he realized that these feelings were related to the search for childhood dynamics. Freud came to believe that the patient's transferential feelings - when properly understood - represented the emergence of repressed feelings towards childhood figures - displaced and projected on to the analyst. Transference was no longer seen as an obstacle but as the way forward. In fact, in psychoanalysis, the analyst was encouraged to become a "blank

screen" so that the client could create project the characteristics of other important figures in his life onto the analyst. Any display of personal characteristics would discourage transference by marring the perfection of the analyst's tabula rasa. (Mitchell, Black, 1995, p. 243)

The ideas about counter transference followed an identical course - just a step behind. Classic psychoanalytic thought considers counter transference as the therapist's response to the client. Freud felt the analyst should be calm and objective and that the transferential material directed at the therapist had nothing to do with the analyst; and the role was just to interpret. Freud's theorized that the patient's desires should be allowed to persist, but not be gratified. It is this aspect, which brings the unconscious impulse to consciousness. The gratification of desires would repeat in real life what should be remembered; acting out is a defense against remembering; the therapist must not yield to temptations but perceive the symbolic content of the actions. The transference was not viewed as resistance but as the focal point to mobilized change. Initially if the analyst had intense feelings about the patient it was thought that something was wrong and the analyst should either do self-analysis or return to their own analyst. Later, there was a shift in thinking about counter transference and seeing the basic unit of mind as an interactive field, that different people evoke different interactions and responses and personality is not static (for either analyst or client and they can be mutually generated). Different theorists took different approaches. Fromm felt the patient needed the analyst's honest and frank reactions but not personal reactions and not acted upon. He considered the analytic reserve could be problematic.

Counter transference became seen to be a valuable tool. Patient's repetitive interpersonal difficulties would impact analyst and the analyst's reactions were key to advancing the work. Object relations saw the repetitive self-object configurations of the patient's inner world and Klein articulated the concept of projective identification as a way to analyze through the therapist the client's dynamics. Kohut believed that counter transference reactions were the result of the therapist's own narcissistic vulnerabilities, that in some way the therapist was not understanding empathetically what the client was going through at that time. Thus it was important for the therapist to acknowledge mistakes to the client or in the case of supervision – the supervisee - and change his or her behaviour. Lacan believed that the desire of the therapist came first. Hillman thought that counter transference begins with the analysts desire to bring health

of awareness, imagination and beauty of life in to the soul of the other. Hillman suggests that it is the therapist's counter- transference, which is prior to the client's transference and ignites the client's transference. The importance of counter transference has been acknowledged and is now seen as the way that the experience of the therapist can become a source of knowledge.

Schaverien, (1992) art therapist and Jungian analyst, proposes that transference also occurs to the art work itself and it can be mediated through the therapist, although this does not preclude transference to the therapist. Racker theorized that the libido mobilized by the therapist's non-judgmental attitude evokes not only the need for love but also the capacity for loving. He speaks of counter transference in terms of the law of talion: a positive transference will generate positive counter transference and a negative transference will evoke a negative response. (Schaverien 1992, p.17)

The term counter transference refers to three different but interrelated phenomena. The primary one that is commonly considered is the therapist's unconscious response to the client's transference. The second meaning of the counter transference is the counterpart to transference and refers to how the therapist will bring his or her own unresolved conflicts and focus them on the client. The third level is inclusive of everything in the therapist's personality that might impact the therapeutic process and relationship. This includes all aspects of the therapist: age, stage of life and experience, performance in multiple roles, life experiences, losses etc. It pertains to the therapist's feelings towards the client and herself in the treatment process. The insight into counter transference can transform your personal experience as a therapist into becoming a source of knowledge.

Beginning therapists often want to deny or get rid of counter transference feelings as soon as possible but really when one considers counter transference as the emotional response of the therapist to the client it is integral to treatment.

Potential warning signs

These are some potential warning signs of the supervisee's counter transference feelings towards his or her client that might manifest in an unconscious manner.

- Being overprotective of a client may elicit dependency that is unsolicited.
- Being overly friendly or trying to be helpful. The client may experience the therapist as patronizing or seductive. Helpfulness can be experienced as intrusive. Even expressing warmth or physical contact without permission can be intrusive. Psychological or emotional intrusiveness can be things like inappropriate self disclosure (meeting the therapist's needs), cognitive intrusiveness can be things like the therapist talking too much, or asking too many questions or making too many interpretations or interpreting too quickly.
- Therapist/supervisee complaining of their workload and responding to client's needs in the evening, weekends or vacations.
- Lack of objectivity and needing to be "right". Making assumptions and expressing disapproval of one or another family member.
- Lack of an authentic response can be experienced as a blocked mirror.
- Lack of balance and self care in the therapist's own personal life.

These are some indicators of transference & counter transference reactions that might emerge in the context of supervision in the supervisee/supervisor relationship:

- The supervisee expresses a desire for the supervisor's approval and there appears to be a feeling of fishing for compliments, and not wanting to upset or disturb the therapist. This might be expressed by excessive self criticism and looking for reassurance and approval.
- The supervisee expresses concern about the supervisor's feelings towards her and expresses a fear of being disliked, boring or inadequate.
- The supervisee expresses extensive curiousity about the supervisor's personal life and relationships.
- The supervisee refers to comments made outside of session either by the supervisor or about the supervisor and is concerned or distressed by them.

- The supervisee tries to move to being a friend. The supervisee phones excessively for advice or support about both professional and personal matters.
- The supervisee idealizes the supervisor and has high expectations for the supervisor to be 'perfect' in all ways. The supervisee acts as if you are their personal guru.
- The supervisee responds negatively to any feedback – citing other instructors or theoretical positions.
- There is ongoing disapproval for differences in opinion. There is the "walking on eggs" feeling and you realize that you are not behaving or expressing yourself normally.
- There are expectations of special treatment and jealousy and envy is evident in relationship to other supervisees.
- There are odd patterns regarding: changing appointment times, being late, leaving early, not being prepared.

Recognizing transference

When you have a disproportionate emotional reaction to an individual or situation, it is highly likely that transference has been activated. This might be a positive or negative reaction. Repetition is another indicator of unconscious transference processes at work; repetition of behaviour, attractions, etc. Transference can occur with only a small percentage of similarity to the original individual. A name or hair colour or behaviour or way of speaking can all be starting points. Transferences come from our internal objects and most commonly stem from our family of origin. This would include mother, father, stepfather, stepmother, brothers, sisters, aunts, uncles, and grandparents. Other significant people or animals are in the range of possibilities. Transferences may have a positive or negative valence.

For example: a supervisee may have a 'positive' mother transference on her supervisor. This may be because the supervisor is giving what she wants and needs and she is like her own good mother –supportive and nurturing and providing positive mirroring. Or it might be a positive transference where the therapist or supervisor is not like her own mother but is giving her what she never had and meeting previously unmet needs of positive mirroring and nurturance. It is possible that this 'positive' transference can activate the grief, rage and envy of what wasn't given as a child.

A negative mother transference may have the client/supervisee responding to therapist/supervisor as if they were always critical, cruel, abusive, unavailable either physically or emotionally, inadequate, or disappointing. The negative transference may be based on actual life experiences or it may be based on the infantile feelings residual from unavoidable life events. Feelings regarding the unavailability of parents may stem from circumstances of illness, disability, depression, losses or hospitalization. It is very important to not make assumptions. Dr. Martin Fisher spoke in a training session about the 'retrospective falsification of facts' that can occur with remembering the feelings and then assuming that it was fact. The example he gave was a woman saying that she was deprived and her memory was of not being given a second ice cream cone when she asked.

As stated previously, transferences can be both positive and/or negative and there will likely be both parts so don't get complacent with a positive transference. It is important to stay aware of both aspects to any transference feelings. If it appears to be all positive then one should then

question where the negative feelings are being directed and if negative where are the missing positive feelings.

Positive transferences may emerge when needs are being met that haven't been met before or are similar to how needs had been met in the past. If they haven't been met before there can be different kinds of reactions from the pleasure experienced in the present to anger that they had missed out previously. With positive "good mother" transference on the therapist then what happens to the 'bad' mother feelings.

Sometimes it is hard to recognize transferences – but attending to the phenomena can be very helpful therapeutically as the therapist can become more aware of the client's reactions and needs in the relationship. This does not mean that the therapist is just to meet all of the unmet needs as this will create an inappropriate dependency on the therapist. It would be gratifying the unconscious desires that should come to light.

These aspects are easy to see in a number of parallel relationships: teacher to student, supervisor to supervisee and art therapist to artist/ client. The student, supervisee or artist/client is dependent and looking for 'help' – support, insight through education, consultation or therapy. The teacher, supervisor or art therapist may experience this as confirming feelings of being of value, wanted and respected and will attempt to give the other what is needed and asked for and the recipient will feel gratitude and this will meet the teacher, supervisor and therapist's need. On the other hand the teacher, supervisor or therapist may be concerned about maintaining appropriate boundaries and feel anxious and even perhaps hostile. The other will feel more and more inadequate. The therapist doesn't feel needed. It is important for the therapist and for the supervisor to be aware of personal 'ego-investment needs'. A self transference can emerge as treating the student or supervisee as if they were themselves at that stage of development, identifying or reacting.

Counter transference feelings can run a whole gamut of emotions including:

1) Anger and rage - at what has happened to the client, at family members, offenders, the system, colleagues. Therapist may feel angry towards the client for not healing faster or responding more positively to the treatment.

2) Guilt - helplessness, survivor guilt, bystander guilt, personal guilt – therapist may feel like becoming a rescuer or overprotective.

3) Fear and disgust – therapist may feel dread and horror – secondary trauma can occur listening to tragic narratives.

4) Denial and avoidance – may result in subtle forms of victim blaming or psychosomatic responses.

5) Grief and mourning – for the client and for the self.

6) Anxiety – about the health and safety of the client and about whether they can help the client.

As stated previously, Lacan and Hillman (1972) write of the motivation or desire of the therapist coming before the client's transference. What is the therapist's motivation to engage in therapy?

What is their need to be 'helpful' or 'therapeutic'? It is important to consider exactly what constitutes "help" or "therapy". Sometimes a therapist's "helpfulness" can in fact be intrusiveness. Examples of this would be for physical intrusiveness, touching a client without asking permission or helping or touching the client's art without asking.

Psychological or emotional intrusiveness might be inappropriate self-disclosure and cognitive intrusiveness could be the therapist talking too much, asking too many questions or making too many interpretations or interpreting too quickly. Training therapists need to be aware of transference and counter transference and projective identification. Supervision allows for the interactive processes between client and therapist to become more transparent.

Counter transference can be seen as the therapist's wish or desire; part scientific curiousity, part reparative, and part parental drives. The therapy with a client allows for the possibility of reparative satisfaction. The client may represent some aspects of the therapist's unconscious still endangered by aggression. There is the possibility of reparative satisfaction in the therapy with a client. "In some aspects the patient stands for these areas within the analyst's own unconscious which are still endangered by aggression and still in need of care and reparation." (Bradley, 1997. p. 52)

It is important for the therapist to be able to cope with a period of uncertainty and a breakdown of understanding (Bradley, 1997). Difficulties of this nature can depend to a certain extent on the criticalness of the supervisee's superego. In supervision the question of how does the supervisee handle his own guilt at the breakdown of communication?

Does the supervisee blame herself, the supervisor or the client? Can the supervisee or the supervisor tolerate personal shortcomings?

Supervision allows for the interactive processes between client and therapist to become more apparent. It is important for all therapists and supervisees to be engaged in both a personal process of self-exploration and a creative process. Just as the client needs to observe their own response so does the therapist need to observe their own responses in order to contaminate the relationship as little as possible. The original Freudian view was that the counter transference would be eliminated by further analysis of the therapist: it was viewed as projection of the therapist's unresolved transference needs into the therapeutic situation. This is still thought of as one dimension but not the whole picture. The therapist responds to the client's reality as well as to their transference. The counter transference is both conscious and unconscious and should be explored to further understand the client.

Naida Hyde, a noted feminist therapist, identified how the desire or motivation of the therapist can be part of the counter transference. She emphasized the importance of therapists not looking to get their own self-esteem needs met through being a therapist. She outlined some areas that she refers to as potential ego investment needs for the therapist (1995). The areas can be considered from several perspectives: from looking at the art therapist as the supervisee or looking at the art therapist as supervisor.

a) The supervisee or supervisor may have a need to be liked and avoid possibility of negative feedback or criticism. Fears around being seen as a "bad therapist or bad supervisor" can contribute to difficulties in setting appropriate limits or boundaries, or in confronting the client or supervisee.

b) The supervisee or supervisor may also try to be especially nice or positive. A good sense of self and of one's own inherent goodness is important. A sound theoretical basis helps to keep an overview of the therapeutic process and the interactive dynamics.

c) The supervisee or supervisor may have a strong need for structure, to be in control and / or to be right. He or she may try to avoid aggressive behaviour like anger, criticism, rebellion, and domination.

d) The supervisee or supervisor may need to feel competent, useful and helpful. While this may come from a desire to do compassionate work it is still important to consider exactly what constitutes "help" or "therapy". Sometimes a therapist's "helpfulness" can in fact be intrusiveness. As mentioned above, these intrusions might be physical, psychological or emotional. "Helpfulness and intrusiveness may represent overprotectiveness, eliciting client dependency, which is then responded to as if it is unwanted and unsolicited. Warning signs of this are when a therapist is complaining (which could be seen as boasting) about the workload, about responding to client's needs in the evening or on the weekends or vacations." (Hyde, 1994)

e) A supervisee may have an unrealistic desire or urgency to be seen as perfect and is desperate to not make mistakes, to not be seen as inadequate, unprofessional or as not knowing. It can be helpful to introduce how Winnicott's concept of the "good enough mother" can be applied to the "good enough therapist". With all the same pitfalls for the client of having a perfect therapist with over idealizing and not being able to live up to the ideal image.

f) The great healer archetype is a variant of this. The supervisee or supervisor may have an unconscious desire or fantasy to be a 'great healer' and although all therapists want to see positive change, it can become a focus of the therapist's need to have the client feel better as quickly as possible. The therapist may need to be all giving, all responsive to client needs for nurturance, support and dependency without allowing oneself the freedom, the right and responsibility to set firm limits and boundaries. (Hyde, 1995)

g) Therapist envy and resentment can arise out of the therapist giving the client what the therapist has not had. This might pertain to what has not been had in childhood or in one's present life. This counter transference may be seen in a 'mother' giving to her child what she didn't have and then resenting not being appreciated. Envy can play a role with

wealthy clients, attractive clients, or successful clients. Envy or resentment can play a role for a therapist either unable to have children or who has lost a child and having a client considering abortion or being angry and resentful about their children. Envy can emerge in a number of ways. For example, providing an opportunity for clients to make art but not taking the time for your own art making. There can also be a boomerang effect of caretaking the client and then feeling used. Art therapists can become envious of clients having the opportunity to create art if they are not taking time for their own creative life.

Scapegoat transference to the art

Schaverien (1992) expanded the therapeutic understanding of the nature of transference and its manifestation in relationship to the artwork by introducing the concept of the scapegoat transference. Scapegoats pertain to the transfer of evil with the attempt to alleviate human suffering by diverting and projecting it out of the individual. A client may express his or her pain or depression in their art and experience some relief by placing it physically outside of the body or further by disposing of the picture. There can be a magical belief in the pain being contained through the expression of creating artwork.

Scapegoating is a form of splitting, of separating the good from the bad, and disposing of the bad. The scapegoat is a universally practiced method of atoning for sins and ridding a community of evil. It comes from a mythical worldview where there is a continuity between cause and effect. Fundamental to the concept of scapegoating is the belief that attributes and states are transferable substances and that evil or illness can be transferred. This is not considered a symbolic substitution but a physical transfer of substances. The scapegoat transference may be observed as it emerges in the artwork. Regression may take place in the picture rather than in the relationship with the picture embodied with emotion. The physicality of creating the artwork and the potential for concrete transference enactment through the art therapy process distinguishes art therapy from related psychotherapy.

Scapegoat ritual related to the art therapy process: 3 steps
(Schaverien, 1992)

1) Sins or evil are transferred to goat or expressed in the art.
2) The goat is magically invested or the artwork is empowered as an object.
3) The goat or artwork is disposed in a manner compatible with the affect it embodies.

Schaverien (1992) discusses how the disposal of the artwork can occur in a variety of ways. It could become a gift; or placed on the wall; thrown in the garbage; destroyed by burning or tearing up; kept in a box or left with the therapist. Images can be disposed of in ways that hold the ritual of the scapegoat transference but that are different as to how you can dispose of people and feelings. Leaving the artwork with the therapist could have a variety of potential meanings. The artist/client may want the therapist to keep the associated feelings safe or keep the feelings separate from family. There may be a desire to forget or to repress; or the split off parts may have been internalized and integrated. Splitting can occur during disposal via the art object; also to permit the enactment may provide a contained resolution of the transference. The final stages of the transference may be resolved by the destruction or banishment of the image or by keeping the image safe through either a gift or appropriate storage. The appropriate disposal of the artwork can bring a relief of the pain and distress. Important to process the disposal of the picture because "the death of the messenger only delays the inevitable acceptance of the news, it cannot erase its content from existence" (Schaverien, 1992). "Resolution of the scapegoat transference depends on conscious understanding of the significance of the disposal of the picture."(Schaverien, 1992)

Mediation & interpretation of counter transference

Reflective counter transference: The therapist can experience a reflection of the artist/client's experience.

Embodied counter transference: The therapist may embody a person from the client's early life or has identified with the client's life experience.

Aesthetic counter transference to the artwork: The therapist has a positive or negative experience viewing the artwork.

Acting out in the counter transference: This can be an unconscious process by which the artist/client may act to relieve tensions in any number of ways – possibly by trying to extend the therapeutic boundaries.

Counter transference enactment: There is encouragement from the therapist to consciously enact the splitting and integration.

Projective identification: This can be considered or thought of as an induced counter transference.

Some basic guidelines to working with transference and counter transference:

It is best to let regressive processes unfold without interruption and to let the transference emerge spontaneously. Don't encourage transference by being overly friendly or trying to be helpful as the client or supervisee may experience the therapist as patronizing or seductive. Avoid making premature interpretations which can be experienced as expressions of disapproval. Observe personal responses, emotions, and thoughts, reflecting on the significance and historical connections. It is important to stay cognizant of the implications of political versus psychological interpretations; the real relationship, the working alliance and the transference (Schaverien, 1992).

A phenomenological approach
- First of all ask for a full description of the relationship and situation:
 - o Pay attention to patterns and repetitions
 - o Listen to the metaphors and the intensity of emotional response.
- Bracket out assumptions:
 - o Bracket out the "problem" and "right or wrong" thinking.
- Context or being-in-the-world
 - o Trace the emotional roots – Historicity.
 - o Explore associations and trace the emotional roots
 - o Client's family dynamics – past and present
 - o Therapist's family dynamics – past and present

o Pay attention to the spectrum of positive and negative transferences – stay aware of the dialectic.
- Pay attention to the spectrum of positive and negative emotions.
- Use free association to explore the feelings of empathy or irritation engendered.
- Consider the dynamics of internal splits and scapegoats.
- Work to separate the transference from the real relationship.

- Intentionality: (motivations and meaning)
 o Therapist/ supervisee:
 - Discuss the experience of being transferred on
 - Attend to the therapist's own feelings to contemplate the extent of the transference.
 o Look at the intention or desire of the therapist.
 - look at the intention or desire of the therapist;
 - It is important that the therapist survives the projections. Look and listen for commonalties, identifications and the possibilities of self transferences

- Essence:
 o Identify the feelings and intuit subjective responses.
 o Listen for the metaphor in the description and then explore for associations.
 o Explore feelings of empathy.
 o Focus on the artist/client's experience and the meaning of their interaction with the supervisee.

Exploration Exercises

Think of your boyfriend/girlfriend, or husband/wife, or a close friend. Think about some aspect of their personality that you have a strong reaction to, either positive or negative. Now write that down on a piece of paper. Describe what that aspect of their personality is like, and how you react in your thoughts, feelings, and behavior toward that part of their personality. Draw a box around what you have written, and write at the top of the box, 'Is this transference?' Now think about your parents. Is the personality characteristic of the person you wrote about, and your reaction to it.... is it a kind of replay or recreation of something that went on in your relationship

with one (or both) of your parents? For example, does your parent have that same personality trait that you react to so strongly? Transference may be more tricky than simply reacting to others the way you reacted to your parent. Here are several possibilities:

- you see the other in the same way as you believed your parent to have been (simple transference)

- you see the other as being like what you WISH your parent COULD have been like

- you see the OTHER AS YOU were as a child and you act like your parent did

- you see the other as you were as a child and you act like you WISHED your parent could have acted

With these added dimensions – there may be a few more connections – or perhaps there are no evident transference aspects. The form "transference" is being suggested in this exercise is a bit different than how it is applied in psychoanalytic theory. We're not talking about a neutral or "blank screen" therapist onto which the patient projects and recreates patterns from childhood.

Animal Hearts and Animal Bodies

Draw a picture of your client and yourself (therapist) as animals. Draw the background and an environment for them. They can be any kind of animal, bird, fish, or insect. They can be real, imaginary, symbolic, or a composite. Draw quickly and express the first idea that comes to mind without editing or discrediting it. The intention here is not to depict how the relationship 'should be' but how it feels and functions.

After making the drawing, take some time to look at it and write a description. Underline themes and key phrases – focus on distilling the essence. Discuss the image and writing with a fellow supervisee or supervisor.

13 THE SHADOW SIDE: IMAGES & NARRATIVES THAT DISTURB

Art therapy can be of value in areas of education, therapy, physical and mental health, social and community development that focus on prevention, rehabilitation and therapeutic treatment. How the art therapy work is viewed and the therapeutic framework and beliefs regarding healing are very important to the well being of the developing art therapist. Viewing the shadow side as a place for learning and growth and being willing to bring light and focus into the darker corners of the psyche can lead to new insight and life energy.

Individuals may be conscious or unconscious about the roots of the emotional pain or difficulties that he or she experience. Unresolved grief from intense or multiple losses, trauma, intrusive experiences and life challenges may hold a significant space in the psyche. Anger, envy, regret, sadness, can be held for extended periods of time. A sense of self and identity may be formed and constructed around pain. The question comes as to what to do with the memories and experiences – is resolution, letting go and forgiveness of self and / or others even possible.

Essentially, the main reason that people come to therapy is because they are experiencing emotional pain or difficulty in some area of their life. It is very unlikely that someone comes to therapy because they are having too much fun. The essence of the therapeutic process and healing is to transform the emotional pain via the creative process and move towards restoring balance, pleasure, and meaning in life. Through that process there may be difficult, traumatic, and painful life experiences to be worked through. Therapy doesn't change the experiences, but it can change how the experience is viewed and the meaning it holds for the individual.

The lives of our clients are often full of very painful, traumatic stories that can at times be hard to hear and hold in a therapeutic frame. Some of

the images in the artwork may reverberate after the session. The therapist/
supervisee may feel a disturbance in equilibrium which may impact his or
her sense of self and safety in the world.

The therapist/supervisee may be shocked by the narrative, the life
experience and by the artwork, however, the manner in which they respond
or hold it will impact the therapeutic process. There are genuinely shocking
events that occur in life and yet what we might perceive as shocking may
have serious and adverse repercussions for the quality of the experience in
the therapeutic process. Both developing art therapists and professional
art therapists will have some potential shocking experiences with their
clients.

I often speak of how we need to let the feelings touch our heart and
then move through us into the earth. It is important not to block the
feelings – if we don't feel empathy we probably shouldn't be doing the work
– or we may be suffering from compassion fatigue. Compassion fatigue is
the current term referring to 'burn out.' In truth, it is my belief that the
best antidote to compassion fatigue is good supervision and professional
development.

It is important not to hold the feelings generated in doing therapy in
our body, or to carry them around with us. It is not helpful to the client to
have the therapist try and take the pain away. The pain is part of who they
are – part of their identity – and they need to find new ways to construct
themselves and make meaning from their life. It can be helpful to give
them more art material to keep on expressing the feelings and images until
they transform.

The experience of shock, rather than only being an entirely negative
and painful state, which we wish to avoid, may also be an opportunity to
help us as therapists identify how within ourselves we may be contracted,
rigid, defended, unaware, fearful, confused, or otherwise limited in our
perception of ourselves and the world around us, including our clients.
When we are able to shift our perception of shock from being a personal
impediment to becoming a therapeutic ally, we may then become more
able to work with this state in a skilled way and generally become better
able to generate a more genuine empathic response to the reality of the
client's felt emotional experience. Thus, we may then become better able
to maintain our genuine therapeutic presence, and also prepare ourselves
for future events of the potentially shocking image and engender a deeper
experience of self-compassion.

'Hormesis' refers to a healthy or growth response biologically to stressors or toxins. Holding this metaphor in mind can be of value in therapeutic work and working with the shocking image.

Martin (2003) deconstructed the experience of shock to several fundamental aspects that are relevant for the context of therapy. Shock – disrupts our perception of the world. We may have a reaction to what appears to be an anomaly and we may withdraw with revulsion, fear, aversion and/or disgust. The client and the client's experience may now be seen as other and outside the boundary of one's own world. On the other hand, the shock may be through identification and perception of resemblance or similarity and we react to the client as if he or she is the same as us. Shock may also precipitate confusion and the reaction can be boredom, sleepiness, numbness, apathy, distraction or indifference. There is uncertainty as to how to react or how to relate to the client.

Martin (2003) identified some of the potential hazards or shocks as:

- The disruption to the therapeutic relationship
 o Loss of self-confidence or disruption to self concept as a therapist or compassionate individual – could be from critical or dissatisfied clients.
 o Differences in expectations for therapeutic outcomes or concepts of health or change.
 o Radical differences in conceptual frameworks (therapeutic, spiritual, political) or the ethical and moral ground between therapist and client.
 o Violence (physical or sexual) that the client has experienced or witnessed and is expressed visually or verbally
 o Violent or sexual feelings and desires that the client expresses visually and/or verbally
 o Intense emotions from the therapist: anger, resentment, frustration, fear, anxiety, feelings of overwhelm

- The disruption of our therapeutic boundaries
 o Client may feel the need to care take the therapist
 o Client may feel that they are bad or too much for the therapist

- o Disruption to our concept of the client – with a client's disclosure that disrupts our assumptions regarding the client and our world
- o Loss of clarity in how to proceed therapeutically

- Transference & counter-transference
 - o Loss of empathy and emotional withdrawal of the therapist
 - o Profound commonalities and differences in personal history and experience
 - o Potential of dissociative states in the art therapist.

- Therapist may self disclose personal trauma history

Our perceptions and reactions are utilized to bring a sense of emotional safety. Although, we will often insist that we have an accurate and truthful experience of reality, our perceptions are often distorted by our emotions, and we try to validate our world view and self concept as normative. This may just seem as the way it is, and we have automatically stepped aside from compassionate and critical thought. Taking the time in supervision to slowly and thoughtfully explore our perceptions, beliefs, and reactions is important. We might ask ourselves:

What do I disown or not want to accept in myself?

What do I dislike, fear, or do not want to take responsibility for in myself?

What do I gain from seeing myself as separate or different from?

What aspects of the client do I identify with?

What am I doing for self care?

What needs am I meeting for myself in this interaction?

What do I not want to know about regarding the client's emotional reality or my own reality?

Could my confusion or distance be a defense against my own issues?

Functions of the shocking image

Although generally speaking, the client is not intending to evoke shock in the therapist – clients may test the ground to see if the therapist can hold the emotional intensity of their life experiences. I have found in some children and adolescent art therapy groups there may be individuals who wish to evoke strong reactions and will express graphically shocking imagery. It is very important that the therapist explore the deeper meanings that the shocking image may hold for the client. Some possibilities of this may include:

- The need for expression and/or catharsis of extreme emotional states such as rage, terror, hatred
- Testing the therapeutic frame – the therapist's trustworthiness, empathy, strength, tolerance, depth of understanding and compassion, fearlessness
- A signal of distress or call for help.
- An expression and/or exploration of transference to the therapist.
- An expression of fear of what the client may find shocking in her/his own life, and therefore what might possibly be an attempt to cultivate a sense of mastery over her/his situation or history of fear.
- Ascertaining therapeutic boundaries/what's appropriate.
- An attempt to normalize an abnormally traumatic life experience.

Activities

Discussion:

Review the following list and identify those forms of the shocking image that evoke the experience of shock for you. Do any particular forms of shock evoke more emotional intensity than others? Would some be more shocking if they occurred in a younger person or a child? Or an elderly person? Or a peer or colleague? Or a family member?

Forms of the shocking image may potentially include:

- Extreme trauma, such as systemic and/or random violence, abuse, torture, or deprivation: ritual abuse and/or cult activity.

- Natural disasters, such as earthquake, famine, accidents, AIDS epidemic.
- Culturally modified disasters, such as war, political terror, riots.
- Threats of harm to self, graphic illustrations of self mutilation, of a suicide plan, of a process of death and dying, and/or images of an imagined afterlife.
- Threats of harm to the therapist, others, children, pets and other animals, property.
- Homicidal intentions.
- Negative transference or other negative feelings directed toward the therapist.
- Disclosure of criminal activity (historical or current).
- Bizarre thoughts and behaviours.

List Poems: rage poems and thank you poems

List poems use an opening phrase to provide the structure of the poem. When introducing an activity like this in an art therapy group or in supervision it is important to give a choice to have the poems read out loud as the experience of being witnessed can function powerfully to hold and honour the rage and the pain. It is also important to bring the participants (clients or supervisees) out of the anger and to introduce another opening phrase that can develop into either individual poems or a group poem. A group poem would be when in a circle participants take the phrase and add a personal ending.

Some opening phrases that I have used are:
I am angry about ….
I am mad about ….
I am in a rage about ….

Some potential phrases which could be used in the context of a closing ritual or for creating either individual or group poems are:
If I could change the world I would …..
I am grateful for ….
I am thankful for ….
I am glad or I thankful of …..

Prayer or blessing:

Another variation for a closing exercise can be the creation of a group 'prayer'. By prayer I mean to refer to a sustained focus on the quality of attention to presence and being.

Pass out small pieces of coloured paper and ask each participant to write a one or two line prayer. Have the prayers placed in a basket and take the basket around to each person to take a prayer – choose a different colour of paper than you wrote on. There can be a number of open ended suggestions or a specific focus depending on the needs of the group. Some possibilities are: to write a prayer of gratitude; of desire; of wishes; of support; of thanks; of gifts to others; of forgiveness.

Exploring the shadow: transforming personal demons

For many years I have utilized the concept of personifying your demons, specifically the demons of self-doubt, and expressing them in the art through drawing or sculpture. Some of the ways of working with them have included gestalt techniques of giving the artwork an "I" voice, or having the image speak or working in terms of transference.

Judith Siano (2004) also gave a good suggestion to a group of students who were anxious about their internal critics, when she suggested that they imagine sending their internal critics down to the hotel on the lake for a fancy champagne brunch while they were busy making art. This idea of giving pleasure to one's demons of self doubt was fresh and successful for the group.

This art therapy activity has been developed from Tsultrim Allione's method of 'feeding your demons' (2008). She does suggest the use of art making as an aspect of the meditative process and I have taken her 5 step process and placed it more specifically in an art therapy context.

> This approach of feeding rather than fighting our demons provides a way to pay attention to the demons within us, avoiding the dangers of repressing what we fear inside ourselves.... When we become aware of our demons and offer them an elixir of conscious acceptance and compassion, we are much less likely to project them onto others.... The process of feeding our demons is a method for bringing our

shadow into consciousness and accessing the treasures it holds rather than repressing it. If the shadow is not made conscious and integrated, it operates undercover, becoming the saboteur of our best intentions as well as causing harm to others. Bringing the shadow to awareness reduces its destructive power and releases the life energy stored in it. (Allione, 2008. p. 20-21)

This process is based on a Buddhist practice and the metaphoric language is based in that tradition. In a different spiritual tradition different metaphors and symbols could be used. In practicing in a culturally sensitive manner it is important to never just someone engage in a process when they are not ready or it feels alien to their belief system. The word 'demon' can evoke negative concepts within certain religious practices – so I would suggest that you find a word or concept that works for you – it could be a dragon, or the shadow.

Step 1: decide on the shadow aspect you wish to work on:

What is draining your energy; dragging you down; "eating" you; what incident has disturbed you recently?

- Old issues; persistent fears; addictions; pain; illness
- Reactions or transferences: obsessions, conflicts, fears
- Emotions that keep coming up – focus on the feeling that arises not the person
- Find the feeling and intensify it. Pay attention to the physical sensations: colour? Shape? Texture? Sound? Smell?
- Choose the first thing that comes to mind – watch for the "oh no, not that, anything but that."
- Repressed demons are more potent and destructive when avoided that when brought into consciousness
- Other demons may be hidden under or related to the first ones
- Locate and observe where you hold the shadow in your body

Step 2: personify the shadow and ask what it needs:

Create an image of the shadow. Personify it and give it animal, human, mythological, or alien qualities. Give shape and form to your perceptions with art materials. Let it form spontaneously from your unconscious as you transform a sensation of feeling into a being – an animate being.

Work with what comes up. It is helpful to give the demon a face, eyes and appendages as it helps with communication.

- Trust the image that appears
- Make eye contact and notice the expression in the eyes
- See if you notice anything you didn't see before – observe closely
 - What size is it?
 - What colour is it?
 - Does it have legs and arms?
 - What is the surface of its body like?
 - How old is it? What gender?
 - What is its emotional state?
 - How do you feel looking at it?
- Ask the creature - 3 questions
 - What do you want from me?
 - What do you need from me?
 - How will it feel if you get what you need?

Don't wait for an answer – change places with the creature. Give the creature an "I" voice – the artwork speak and give voice to the answers.

- Imagine yourself as the creature– you are metaphorically in their shoes – adjust to your new identity before answering the questions.
- Answer the questions out loud and in the first person from the shadow creature's point of view:
 - What I want from you is...
 - What I need from you is...
 - When my need is met, I will feel...

Step 3: nurture the shadow and meet your ally: (the ally is a helper or guide)

- Nurture the shadow – to meet its needs

- Face the shadow - separate your awareness from your body – keep your consciousness as an observer of the process

- Imagine nurturing the shadow from your metaphoric self – this could be your body melting into nectar that consists of whatever the shadow needs – give form to the nectar.

- Focus on the shadow and the process of transformation:
 - What happens when it is completely satisfied?
 - Does its appearance or behaviour change?

- Focus on meeting an ally: create art that would give form to the ally and ask the ally any or all of the questions:
 - How will you help me?
 - How will you protect me?
 - What commitment or promise can you make to me?
 - How can to connect to you?

- Change places and become the ally: Answer the questions in the first person "I..."

- Imagine receiving the help and feel the ally melting into you as an inseparable part of you.

Step 4: reflective writing

Write a description of the experience - record in detail the steps with thoughts, memories, and associations.

- Questions to explore:
 - What was the shadow? Describe it and where it was located and the look in its eye.
 - What was it like to become the demon? What did it want? Or need?
 - What feeling was it looking for?
 - What did you feed it? How did it change? What remained?
 - What did your ally look like? What did I learn about it?
 - How will this affect my everyday life?
 - How can I access my ally?

- Read your writings and look for horizons

- Underline significant words or phrases

- Distill into a poem

Step 5: working with a partner as witness

One person takes the active role and one acts as witness: the witness sits perpendicular to the active partner. Agree to confidentiality and to be supportive, and non-judgmental. The witness is to hold the space and be an empathetic presence and to help the individual stay on track. The witness is to observe closely and he or she can scribe – write down what is said. The role of the witness is to guide the active partner through the steps – asking what is happening now and if the shadow is satisfied.

14 POSTCARDS FROM AFAR: ONLINE SUPERVISION

When thinking of supervision as on a spectrum between education and therapy, initially I would have said that online supervision was more educational. When online distance supervision first started, I was very suspicious and thought that only quality supervision could be given face to face. But when the Kutenai Art Therapy Institute had a distance student whose local supervisor moved away and we couldn't locate another registered art therapist in her city, I decided to try it. We had several advantages in that she had attended intensive course work on site and we had already developed a strong working alliance.

Several strengths immediately became evident: the supervisee was very well prepared, she had organized questions regarding the clients, the art work and notes to send via email and then we had a pre-arranged phone consultation. There was no time wasted. The supervisee had given considerable thought to what she wanted to ask and wanted to talk about. We could both see the artwork and look at the notes together.

Initially, it was more difficult to work with transferences or rather for myself as the supervisor to be alert to physical cues. However, I did become more attuned to voice tone, hesitations and gaps in the dialogue. Also, as the supervisee developed skills, she wanted to explore these issues deeper. The introduction of art-based supervision exercises and encouragement of post-session art deepened the process of self reflection for the supervisee. I did have an onsite visit and spent two days with this student visiting the practicum sites, which served to increase my understanding and ability to ask appropriate questions.

The next student that I supervised online decided to do a heuristic research project doing art base supervision. Her thesis is called Embracing Art in Supervision: Cultivating an Identity (Riehl, 2010). Both of these

students were highly motivated and utilized supervision very well, developing into very good art therapists and through the process I have learned to recognize and value the process of distance online supervision.

Protocol, process and expectations

The supervisee reports (weekly or bi-weekly as arranged) on sessions, or non-sessions (clients don't show), sending images of the artwork, notes - which include the process of the session, the feelings of the therapist and an overall general picture of what has taken place. Two or three pertinent questions relating to the placement, the pathology, the session or the art therapy process or the wishes of supervisee, etc. should be formulated with each supervision report. Images of the artwork are sent by digital camera or by scanner.

The supervisor responds to written reports and images through regular weekly or bi-weekly phone meetings.

Supervision can include art-based supervision activities. A number of art directives can be given, or spontaneous post-session art can be recommended or suggested. The introduction of the supervisee's own artwork brings more emotional, physical and unconscious material to the fore. It is both helpful for the supervisee in the process of making the art and writing about it and then having it witnessed by the supervisor with perhaps other questions asked or thoughts reflected.

Direct contact with the supervisee helps to develop the supervisory relation. Ideally there will have been an opportunity for the supervisee and supervisor to meet in person, in the beginning and periodically through the process.

Practical considerations & limitations of responsibility

First of all: clarify the limitations of responsibility. It is important that onsite supervisor for student interns assume legal and clinical responsibility for the supervisee's actions. Online supervision is a process of consultation regarding the art therapy process, clinical issues and dynamics. A signed contract should outline responsibilities and protocol.

Process: supervisees are responsible for_obtaining the appropriate consents prior to discussing or sending any case-sensitive information. All identifying information must be removed or disguised from any and all case related material in order to safeguard client confidentiality. Computer files and emails must be deleted after review.

Confidentiality: the supervisor must delete all files of artwork and case notes after the supervision session. No materials will be returned or kept in file for any reason whatsoever.

Advantages of online supervision

- Choice of supervisor is not limited to location, but can pertain to an area of specialization or clinical background;

- Supervision times can be more flexible and don't require travel time;

- Confidentially can be maintained with attention to privacy and direct email contact.

- Anxiety can be reduced: without the supervisor actually present, some individuals raised in the digital age are more relaxed.
 o Some people find it easier to express themselves with words or to have prepared what they want to say or ask about;

- Efficiency and clarity: detailed writing of notes can be a first step in reflecting on the session;

- Bracketing assumptions: the disadvantage from not having the visual gestural cues can become an advantage in that it can provide a specific caution regarding making assumptions about the other person. Communication may need to be clarified – to maintain clarity and understanding.

While there are many advantages to face to face supervision, I have found that quality supervision can be provided in a distance format. This type of supervision does require more preparation from the supervisee and a different quality of listening and attentiveness to nuances from the supervisor. With increasing numbers of art therapists being hired and working in distance and rural communities, this format can provide a solid ground of support for individuals where there is not another art therapist for miles and miles.

15 HOMECOMING AND VISION OF NEW JOURNEYS

As we come to the end of the journey and look forward to being at home, there are dreams and visions of what one will see and where one will go 'next time'. The journey takes on new meaning as one reflects in the arm chair or sitting on the porch. As students/supervisees complete their supervision requirements for training and move on into the work field or as professional art therapists become registered art therapists – one hopes that each individual has gained a meaningful relationship with his or her internal supervisor.

In many ways the supervisory process is about the development of the internal supervisor – the self reflective capacity and curiousity to explore without premature closure on meaning. There is a two-fold process of being able to pose the questions and to being able to answer the questions without editing or censorship. The inner knowing or rightness of an approach will resonate when it comes to light. In many ways I think we have to just get out of the way of ourselves as therapists trying to 'do' something and allow the therapeutic process to occur naturally.

Learning the hermeneutic phenomenological method to art therapy supervision gives the professional art therapist a framework for self or peer supervision. The art based supervision exercises can be of value in seeking the essence of the issue. Often it is really as simple as learning to ask the right question.

Professional art therapists are often asked or expected to supervise others. Learning to be a supervisor will bring to mind the things that you liked and didn't like about your own experience of supervision. You will find yourself reflecting on what you learned, how you learned and what things left you feeling more inadequate than before. Monica Franz (2003)

identifies in her thesis the need for training supervisors and notes that not all therapists will make good supervisors.

In the process of developing the Kutenai Art Therapy Institute I began to look deeply at the process of supervision and the need to articulate a method with and the underlying beliefs for the techniques used. I became concerned for my graduates heading north to work as art therapists when they were the only ones for miles around. This was before email and phone supervision were realistically available. This book is the result of thinking about the kinds of questions and processes I would engage in during supervision and how to teach professionals a supervision method that would help them sort out problems and untie knots either on their own or with others.

In fact, the exploration of hermeneutics and phenomenology came about because I was frustrated in the professional art therapy world in the 1980's and 1990's where there was a lot of territorialism regarding different art therapy approaches and privileging of one art therapy approach over another. It was my observation that it was the quality of therapeutic presence and the process of engaging in creative art making that was what really made the difference, not whether someone worked from a Freudian, Jungian, Adlerian, Gestalt approach – or some other way. I valued skill and quality in many areas and started to look for a theory that could really focus on the creative process and was introduced to phenomenology by Blake Parker, my late husband. I realized that Merleau-Ponty's description of the attitude of a phenomenologist spoke to the way of being that I felt was essential to being an art therapist. Through the process of working and developing art-based exercises integrating these concepts I met Judith Siano, 'my sister from the other side of the world', and found that she was also working with a phenomenological method of art therapy.

In essence, the phenomenological method fosters an attentive sense of wonder in the world and hermeneutic practice continually aims at open-ended interpretation, the recognition of bias, and the relating of part to whole and whole to part. The hermeneutic phenomenological method applied to art therapy considers both the art and art making as text and the writing as text. It holds that meaning will continually emerge and that there will always be the possibility of new meanings. In training art therapists and in training art therapy supervisors it is the development of the attitude of the phenomenologist that we are trying to achieve. The ability to perceive with openness and wonder, the ability to describe

without explaining, judging or making assumptions, the ability to look with intention and to consider everything in context and relationship, and to intuitively distill the essence are integral to the process of therapy and supervision. For an art therapist this method can be used in the therapeutic session, in the process of reflecting on the session through writing and art making and in supervision.

Phenomenology has been a philosophical method that has used writing as its mode of inquiry. I would suggest that art therapy provides an opportunity to use not only writing but to also include engaging with the art and the creative process as text. To write is to draw us in through words. Writing in a phenomenological inquiry is based on the idea that no text is ever perfect, no interpretation is ever complete, no explication of meaning is ever final, and no insight is beyond challenge (Van Manen, 1990). The art making in supervision can function to mediate the supervisory relationship. It has the opportunity to bring in the unknown.

I believe that the attitude of the phenomenologist is important for an art therapist. It is important to stay open to new meanings being revealed and to never impose an interpretation as fact but to use interpretation to shed light and provide the possibility of understanding and the development of new meanings. But how does insight and interpretation come to light? Insight can occur as the artist/client is involved in creating the art and/or when he or she enters into a dialogue with the therapist about their art. Art therapists have conscious or unconscious interpretive frameworks, which give direction to their questions, frame their clinical responses and set a tone for their reflections regarding the artwork. The problem is how to teach openness towards interpretation while communicating the need for restraint concerning certainty. The intention is to look at the art in a curious and reflective posture open to learning and insight.

The beauty of looking at the artist/client's artwork in supervision is that we can explore possible interpretations. Without insight into symbolic interpretation there would be no direction to the questions asked. So looking at the art in supervision is a safe way to develop skills in exploring metaphors, elucidating symbols and practicing a phenomenological unfolding of the images in the artwork. (Carpendale, 2009)

Looking at the art is similar to when working with a client. With a client one moves and flows with his or her focus and tries to expand the view but one never has time to exhaust the possibilities of symbolic

significance. So looking at art in supervision gives the time for another look at the art and to pose, muse about other possible questions, directions. What we see in supervision is what is presented to us by the supervisee – the art is the only actual relic of the therapeutic exchange. The artwork represents the client. It is the third point in a triangle, which includes the supervisor and the supervisee. Looking at the art avoids some of the problems of remembering the session or distorting by selective memory. Viewing the image brings a tangible part of the session into supervision, which can be re-experienced (Malchiodi, Riley, 1996).

The art work functions in supervision to bring the real situation into a tangible, visible concrete reality (Malchiodi, Riley, 1996). It enables the creative activity to mediate the supervision. It brings the presence of the artist client in to the supervision session. It brings in the unknown and unconscious aspects of the artist client and the supervisee/ therapist relationship from the therapeutic session into the supervisory session. It gives an opportunity to ask about what you see rather than what the supervisee has seen and has decided to tell you about. Supervision without the art present is kind of like having an art show where there is no pictures hanging and the artist walks to each numbered spot and tells the viewers what each piece of art is about without the audience being able to see the art work for themselves. In this situation we could hear the narrative, the metaphors and the associations but we don't see the actual artwork and have our own perceptions and response to it.

The hermeneutic phenomenological method applied to art therapy supervision considers the art, the art making, the writing, therapeutic relationship and the supervisory relationship as text (Betensky, 1995, Carpendale, 2002, 2009). It holds that meaning will continually emerge and that there will always be the possibility of new meanings. The ability to perceive and describe with openness and wonder, the ability to describe without explaining, judging or making assumptions, the ability to look with intention and to consider everything in context and relationship, and to intuitively distill the essence are all important therapeutic qualities. For an art therapist this method can be used in the therapeutic session, in the process of reflecting on the session through writing and art making and in supervision.

In completing this book I am very aware of the imperfections and of how much more could be said and the examples that could be given. As a fellow traveler on the journey, I am aware that I have just grazed the surface of the process. One of the things that I absolutely love about supervision is that it is always new and fresh, never boring, there is always the unexpected. There is the opportunity to learn, grow and find out how to draw the very best out of my supervisees. I think the essential piece is that they learn how to be more authentically themselves.

Best wishes. Send a postcard. I would love to hear from you and to know if these thoughts and reflections have been of value. I also love collecting stamps and putting them in my art.

REFERENCES

A Gardener's journal (2010) Victoria, Canada: Those Great Little Books

Allione, Tsultrim. (2008) Feeding your demons. New York: Little, Brown and Company.

Arrien, Angeles. (2007) The Second half of life: Opening the eight gates of wisdom. Boulder, Co.: Sounds True.

Bedard, Martine. (2001) Post-session art making: the art of not knowing. Nelson, BC: Kutenai Art Therapy Institute thesis.

Bachelard, Gaston. (1994) The Poetics of space. Translation from French by Maria Jolas. Boston: Beacon Press.

Barnet, Sylvan. (1993) A short guide to writing about art. 4th Edition. New York: Harper Collins College Pub.

Betensky, M.G. (1995). What do you see? Phenomenology of therapeutic art expression. London, UK. Jessica Kingsley Publishers.

Brittain, Lambert W. (1979). Creativity, art and the young child. New York, NY: McMillan Publishing Co.

Bourgeault, Cynthia. (2010) The Meaning of Mary Magdalene: discovering the woman at the heart of Christianity. Boston & London: Shambala Press.

Bradley, Jonathon. (1997) *How the patient informs the process of supervision: the patient as catalyst.* In Shipton, Geraldine (Ed) Supervision of psychotherapy and counselling: making a place to think. Buckingham: Open University Press.

Brown, Chris, Meyerowitz-Katz, Julia, Ryde, Julia. (2007) *Thinking with image making: supervising student art therapists.* In Shaverian & Case (ed) Supervision of art psychotherapy. London & New York: Routledge.

Campbell, Jean. Liebmann, Marian. Brooks, Frederica. Jones, Jenny. Ward, Cathy. Ed. (1999) Art therapy, race and culture. London: Jessica Kingsley Pub.

Carpendale, Monica. (2002) Getting to the Underbelly: Phenomenology and Art Therapy. CATA Journal, Winter, Vol 15 #2.

Carpendale, Monica (2009) Essence and praxis in the art therapy studio. Victoria, BC: Trafford Pub.

Casement, Patrick. (1985) On learning from the patient. London: Tavistock Pub. Ltd.

Chodron, Pema. (2005) No time to lose: a timely guide to the way of the bodhisattva. Boston, Mass.: Shambala Pub.

Damarell, Barrie. (2007) *The supervisor's eyes.* In Shaverian & Case (ed) Supervision of art psychotherapy. London & New York: Routledge.

Dostal, Robert J. ed. (2003) The Cambridge companion to Gadamer. New York: Cambridge University Press.

Driver, Christine & Martin, Edward. (2005) Supervision and the analytic attitude. London: Whurr Publishers, Ltd.

Edwards, David. (1997) *Supervision today: the psychoanalytic legacy.* Supervision of Psychotherapy and Counselling: Making a Place to Think. Buckingham: Open University Press.

Feng, Gia-Fu, English, Jane. (translation, 1972) Lao Tsu: Tao Te Ching. New York: Vintage Books.

Ferrara, Nadia. (2004) Healing through art: ritualized space and Cree identity. Montreal: McGill-Queen's University Press.

Fiske, John. (1982) Introduction to communication studies. London and New York: Methuen & Co. Ltd.

Franz, Monica (2003) Clinical Supervision and Therapy / Counseling: Personal, Ethical, and Professional Implications of Dual Service Provision. Seattle: City University unpublished thesis.

Gadamer, Hans-Georg. (1975 copyright/2006 revised edition) Truth and method. London, New York: Continuum.

Gregory, Richard L. ed. (1987) The Oxford companion to the mind. Oxford University Press.

Hays, Pamela. (2001) Addressing cultural complexities in practice: a framework for clinicians and counselors. Washington: American Psychological Association.

Hillman, James. (1972) The Myth of analysis. New York: Harper Torch.

Hiscox, Anna R., Calisch, Abby C.ed. (1998) Tapestry of cultural issues in art therapy. London: Jessica Kingsley Pub.

Kidd, Sunny D., Kidd, James, W. (1990) Experiential method: Qualitative research in the humanities using metaphysics and phenomenology. Peter Lang Publishing Inc., New York.

Kramer, Edith, Gerity, Lani. (2000) Art as therapy: collected papers. London: Jessica Kingsley Pub.

Kramer, Edith. (1971). Art as therapy with children. New York, NY: Shocken Books.

Lahad, Mooli. (2000) Creative supervision: the use of expressive arts methods in supervision and self supervision. London: Jessica Kingsley Pub.

Laine, Ritta (2007) *Image consultation: supporting the work of art therapists.* In Shaverian & Case (ed) Supervision of art psychotherapy. London & New York: Routledge.

Levick, Myra. (1983) They could not talk and so they drew. Springfield, Illinois: Charles C. Thomas Pub.

Lidmila, Alan. (1997) *Shame, knowledge and modes of enquiry in supervision.* Supervision of psychotherapy and counselling: Making a Place to Think. Open University Press. Buckingham.

Lowenfeld, Viktor & Brittan, Lambert, W. (1947) Creative and mental growth 8th edition. Englewood cliffs, New Jersey: Prentice Hall Career & Technology.

Lusebrink, Vija Bergs. (1990) Imagery and visual expression in therapy. New York & London: Plenum Press.

Lye, John. (1996) Some Principles of phenomenological hermeneutics. Website.

Malchiodi, Cathy & Riley, Shirley. (1996) Supervision and related issues: a handbook for professionals. Chicago: Magnolia Street Pub.

McCreight, Tim.(1996) Design language. Brynmorgen Press, Cape Elizabeth, Maine, USA.

Merleau-Ponty, Maurice. (1969). *An Introduction to Phenomenology. What is Phenomenology?* Bettis, Joseph, Dabney. Ed. Phenomenology of Religion. SCM Press Ltd.

Messer, S. Sass, L. & Woolfolk, R. ed. (1988) Hermeneutics and psychological theory: Interpretive perspectives on personality, psychotherapy, and psychopathology. New Brunswick and London: Rutgers University Press.

Metzner, Ralph. Phd. (1999) Green psychology: Transforming our relationship to the earth. Rochester, Vermont: Park Street Press.

Moon, Bruce (2000) Ethical issues in art therapy. Springfield, Illinois: Charles C Thomas Publisher, Ltd.

Mollon, Phil. (1997) *Supervision as a space for thinking.* In Shipton, Geraldine (ed) Supervision of psychotherapy and counselling: making a place to think. Buckingham: Open University Press.

Nucho, Aino.(1987) The Psychocybernetic model of art therapy. Springfield, Illinois: Charles Thomas Pub.

Parker, William. (2008) The Development of an ecological identity. Dalhousie, Halifax: MA Thesis.

Parker, Blake. (2006) A Framework for interpretation. Nelson: Kutenai Art Therapy Institute,

Pickvance, Deborah. (1997) *Becoming a Supervisor.* Shipton, Geraldine ed. (1997) Supervision of psychotherapy and counselling. Buckingham: Open University Press.

Pelletier, Wilfred. Poole, Ted. (1973) No foreign land: the biography of a North American Indian. Toronto: McClelland and Stewart Limited.

Polanyi, Michael. (1967) The Tacit dimension. London: Routledge & Kegan Paul Ltd. Anchor Books.

Riehl, Gerri Ann. (2010) Embracing art in supervision: cultivating an identity. Nelson, BC: Kutenai Art Therapy Institute: thesis.

Riley, Shirley. (1999) Contemporary Adolescent Art Therapy. London: Jessica Kingsley Pub.

Robbins, Arthur ed. (1988) Between Therapists: Processing of Transference / counter transference Material. London: Jessica Kingsley Pub.

Robbins, Arthur. (2007) *The Art of Supervision.* In Schaverian & Case (ed) Supervision of art psychotherapy. London & New York: Routledge.

Roy, Ranju. (1999) *Culturally sensitive therapy: accents, approaches and tools.* Campbell, Leibmann, Brooks, Jones, Ward. Art Therapy, Race and Culture. London: Jessica Kingslye Pub.

Rozak, Theodore; Gomes, Mary E.; Kanner, Allen D. (1995) Ecopsychology: restoring the earth, healing the mind. San Franscisco: Sierra Club books.
Shapiro, Elan. (1995) *Restoring habitats, communities and souls.*
Macy, Joanna. (1995) *Working through environmental despair.*
Sewall, Laura. (1995) *Ecopsychology*

Schaverien, Joy. (1992) The Revealing image: analytical art psychotherapy in theory and practice. London: Routledge.

Schaverien, Joy & Case, Caroline. (2007) Supervision of art psychotherapy: a theoretical and practical handbook. East Sussex: Routledge.

Searles, Harold F. (1965) Collected papers on schizophrenia and related subjects. New York: International Universities Press.

Shipton, Geraldine ed. (1997) Supervision of Psychotherapy and Counselling. Buckingham: Open University Press.

Siano, Judith (2004) An Introduction to Art Therapy: The Haifa University Approach for Phenomenological Observation. My Personal Doctrine. (unpublished paper)

Simon, Rita. (1990) The Symbolism of style. London: Routledge.

Sturrock, John. (1986) Structuralism. Paladin Grafton Books.

Thomashow, Mitchell. (1995) Ecological identity: Becoming a reflective environmentalist. Massachusetts: MIT Press.

Tobin, Bruce A. (2008) Expressive therapies now: action oriented creative arts strategies for healing and growth in children and youth. Victoria: Kleewyck Press.

Van Deurzen-Smith, Emmy. (1988) Existential counselling in practice. London: Sage Pub.

Van Manen, Max. (1990) Researching lived experience. London, Ontario: Althouse Press.

Van Manen, Max. (2002, 2011) www.phenomenologyonline.com

Wagner, Roy. (1986) Symbols that stand for themselves. Chicago: University of Chicago Press.

Ward, Glenn. (1997, 2003) Teach yourself postmodernism. London: Hodder and Stoughton Ltd..

Watkins Jr., C. Edward. ed. (1997) Handbook of psychotherapy supervision. New York: John Wiley & Sons, Inc.

Wilson, Laurie. Riley, Shirley. Wadeson, Harriet. (1984) Art Therapy Supervision. AATA Journal October, Vol. 1. #3.

Winnicott, W.D. (1971). Playing and reality. New York: Routledge.

Winter, Deborah Dunann, Phd. (1996) Ecological psychology: Healing the split between planet and self. New York: HarperCollins College Pub.

Workshops:

Allen, Jan, B.Ed, M.Ed; Lett, Warren, BA. B.Ed, Ph.D.; Morrish, Andrew, Dip. Teach-Primary. Experiential supervision Through the Intersubjective Dialogue: a Workshop for therapists. AATA Conference 1996, Philadelphia.

BCATA conference 1987. Workshops with Helen Landgarten, and Leigh Files.

BCATA conference, Nelson. 2000. Panel comments from Colleen Gold, Jacqueline Fehlner.

Martin, Jocelyn (2003) Working with the shocking Image. Kutenai Art Therapy Institute.

Siano, Judith. (2004) Art Therapy Supervision workshop. Kutenai Art Therapy Institute.

APPENDIX 1. A MODEL FOR DESIGNING GROUPS

I. An Overview of the Whole Situation:
 A. Context and Environment:
 1. Client population:
 a. ages;
 b. sex;
 c. cultural and/or ethnic background;
 2. Type of organization:
 a. short and/or long term mandate;
 b. residential or outpatient;
 3. Funding structure:
 a. 1 or 2 group leaders;
 b. size of group;
 c. materials and snack;
 4. Physical space available:
 a. sound factors;
 b. safety factors;
 c. movement possibilities
 d. creative possibilities.

II. Assessing Client Needs:
 A. Research Treatment Issues:
 1. Intake interview;
 2. Referral list;
 3. Present clients in individual sessions;
 4. Presenting problems and behavioural concerns.

B. Define Client Needs:
1. Developmental needs.
2. Physical needs.
3. Needs relating to the trauma.

III. Set Basic Treatment Goals and Realistic Objectives:
A. Goals and objectives:
1. individual and group goals;
2. short and long term goals;
3. overall structure;
4. focus of activities.

B. Type of Group:
1. therapeutic;
2. educational;
3. support
4. social skills and self-esteem.

IV. Creating a Group Structure
A. Pre-requisites for group membership:
1. personal background (abuse, alcohol, etc.)
2. age
3. sex
4. group readiness
5. treatment issues

B. Basic Structure:
1. drop-in or closed group;
2. on-going or specific number of weeks;
3. length of time per session;
4. time of day offered;
5. arrival and departure of group members.

C. Housekeeping Details:
1. space and location of group;
2. snack and materials;
3. clean up.

V. Designing the Group Sessions:
A. Stages of the Group:
1. beginning;
2. middle;
3. closing.

B. Structure of Each Session:
1. beginning;
2. middle;
3. closing.

C. Choosing and Developing Activities:
1. interactive & expressive;
2. informative;
3. creative;
4. supportive.

VI. Evaluation of Group:
A. Individual Assessments, Records, and Charts.

B. Client Evaluation at the End of Sessions:
1. verbal
2. written

C. Follow-up Assessment

APPENDIX 2: SOME POTENTIAL TREATMENT GOALS:

1. To enhance self-esteem by:
 a. Addressing personal values and strengths
 b. Improving body image
 c. Relieving feelings of guilt and responsibility
 d. Enhancing emotional self awareness

2. To improve communication skills in the following areas:
 a. Listening and speaking
 b. Expressing and accepting feelings
 c. Responding to verbal and non-verbal cues

3. To improve social skills and social interaction by:
 a. Developing skills in empathy
 b. Developing skills in reciprocal engagement

4. To improve coping and problem solving skills by enhancing:
 a. The ability to adapt
 b. The ability to make choices
 c. The ability to tolerate frustration

5. To enhance assertiveness and awareness of:
 a. Personal safety and self protection
 b. Appropriate boundaries and privacy

6. To strengthen flexibility and resiliency in responding to stress by:
 a. Developing creativity
 b. Developing self-mastery.

ABOUT THE AUTHOR

Monica Carpendale, BFA, DVATI, RCAT, BCATR, a Registered Canadian Art Therapist, is the founder and executive director of the Kutenai Art Therapy Institute in Nelson, BC. She has over 30 years of experience in education, art therapy, and supervision. Monica Carpendale is a past president of the BCATA and served on the Canadian Art Therapy Association executive for 8 years as the Registrar and Vice President. Monica has published several articles in the Canadian Art Therapy Journal and authored Essence and Praxis in the Art Therapy Studio (2009). She has presented nationally and internationally on a phenomenological approach to art and poetry therapy, supervision and eco art therapy.

She has produced 3 art therapy documentary films: Art of Lorraine Beninger, about the value of art therapy with a woman who has multiple disabilities, An Angel with a Broken Wing, documenting an art review with a woman living with chronic post-traumatic stress disorder; and Not Broken, Richard Campbell's film demonstrating the use of the medicine wheel in art therapy. Monica also developed and co-designed the series of nine Blue Heron therapeutic communication board games with Blake Parker.

For Monica, making "art" and making "special" has always been a way of life for her. Drawing, painting, gluing and taping together have been ways of creating the world and connecting with others. Monica has lived for many years in the West Kootenay area of British Columbia. One of her current projects is developing an Eco Sculpture Park at the Vallican Whole Community Centre.